LEGENDA OF

NORCO

CALIFORNIA

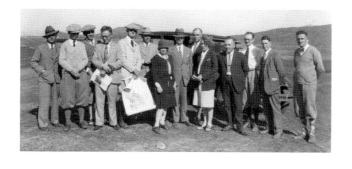

Norco

Once known as the "poultry capital of California," Norco became a haven for equestrians beginning in the early 1950s and today is branded "Horsetown USA." The community of half-acre lots, horse trails on most streets, and plentiful parks is an open-space oasis surrounded by a sea of Southern California concrete. This photograph was taken at Lake Norconian, with the legendary resort in the background. (Courtesy of Brigitte Jouxtel.)

Pagel: Pioneers

Rex Clark, the founder of Norco, stands at center, in striped tie, with the forgotten men and women who, beginning in 1920, built a community under the toughest of conditions and constructed the fabulous Norconian Resort. The resort was known both as a masterpiece and as "Rex's Folly." While the magnificent resort failed, Norco today is a unique and thriving community famous for stubborn independence, volunteerism, and conservative thought. (Courtesy of University of Southern California.)

LEGENDARY LOCALS

OF

NORCO

CALIFORNIA

KEVIN BASH

LEGENDARY
LOCALS

Legendary Locals is an imprint of Arcadia Publishing
Charleston, South Carolina

Printed in the United States of America

Library of Congress Control Number: 2015946638

For all general information, please contact Arcadia Publishing:
Telephone 843-853-2070
Fax 843-853-0044
E-mail sales@arcadiapublishing.com
For customer service and orders:
Toll-Free 1-888-313-2665

Visit us on the Internet at www.arcadiapublishing.com

Dedication
To my mother and father, Betty and Allen Bash, and my truly talented wife, Brigitte

On the Front Cover: Clockwise from top left:
Norco High School principal Lisa Simon and graduating senior Aaron Williams (Courtesy of Gary Evans; see page 42), Constable Hugh Underhill at his Norco ranch (Courtesy of Debbie Talbert; see page 48), Norco Fair Parade grand marshal Rose Eldridge (Courtesy of Barbara Hill; see page 35), North Corona Land Company director Rex S. Clark (Courtesy of Peter Clark; see page 16), Kara Lubin and the 100 Mile Club (Courtesy of Kevin Bash; see page 107), Capt. Leslie Marshall pins medal on Capt. Harold Jensen (Courtesy of University of Southern California; see page 86), Pete the Dog of *Our Gang* fame (Courtesy of Kevin Bash; see page 71), Lois Richards, city historian (Courtesy of Richards family; see page 47), Mr. and Mrs. John Hamner (Courtesy of University of California Riverside; see page 20).

On the Back Cover: From left to right
Wounded warrior Jason Fairchild and Patriot Guard escort (Courtesy of Brigitte Jouxtel; see page 120), Karlene and Bob Allen at their "Christmas Tree Farm" (Courtesy of Brigitte Jouxtel; see page 36).

CONTENTS

ACKNOWLEDGMENTS

Thank you to the following libraries and archives that graciously allowed use of their images. The following sources are credited with abbreviations at the captions: Corona Public Library Board of Trustees (Corona), University of Southern California (USC), Norco High School (NHS), Orange County Archives (OCA), University of California, Riverside (UCR), City of Norco (Norco), and Mayo Clinic Historical Unit (Mayo).

Thank you also to the remarkable and cultured Peter Clark, grandson of Norco founder Rex Clark, who graciously provided his father's (Rex Scripps Clark) marvelous images of early Norco and great insight into his family's founding of the community and building the Norconian (Clark).

Thank you to the local photographers who graciously donated their photographs: the fabulous Gary Evans; my wonderful wife, Brigitte Jouxtel; Mike Hickey; John Casper; Matt Cohen; Rudy Ramos; Richard Fields; and Jerry Soifer.

Thank you to the late Ellen Revelle, who spent wonderful hours sharing stories of her father, Rex Clark, her mother, Grace Scripps Clark, and the rest of her family as they pioneered Norco.

Thank you to the following people for their stories, photographs, and assistance: the fabulous Jeanne Easum, Andre B. Sobocinski, Diane Hill, Cara McCray, Ruth McCormick, Tamara Ivie, Cara McCray, Mary (Moreno) Hall, Michael Hanzlik, Huell Howser, Lorin P. Meissner, Elizabeth Kinzer O'Farrell, Eddie Musquez, Charles Roth, Don Stowe, Edna Johnson, Florence and Ollie Marlow, Gina L. Nichols, Jennifer Marlatt, Trixy Betsworth, Ron Snow, Dace Taub, Christina Rice, Mark Wanamaker, Betty Bash, Bill Wilkman, Kathy Azevedo, Rochelle Wallace, Hal Clark, Ray Harris, Robert Peister, Gene Peister, Bob Allen, Jim Allen, Karlene Allen, Phil Newhouse, Debbie Stuckert, Sammy Lee, Rudy Ramos, Benjamin Cricket, Mike Nugent, Rueben Lemus, Lolita Lemus, Augie Ramirez, Larry Key, Pat Barker, John Barr, B.J. Hill, George Milner, Shirley Gilbriath, Harold Davis, Jack Gordon, Don Williamson, Howard Hanzlik, Red Taylor, Lesley Mathews, and Frank and Edna Day.

Unless otherwise noted, all images appear courtesy of the author. And, unless otherwise noted, the *Corona Daily Independent* provides all quotes.

INTRODUCTION

Norco is a Southern California city of 15 square miles located in far-reaching Riverside County. The community began in 1909 as a speculative development, Citrus Belt, that promised economic stability to anyone willing to work hard enough to bring in a cash crop. Unfortunately, the area's brutal Santa Ana winds, frost, lack of a reliable water system, and the hardpan soil derailed many a hopeful farmer.

Rex B. Clark, part visionary, part saint, and part flimflam man, arrived on the scene in 1920 and renamed the community "Norco." From its beginnings as a watermelon and lettuce hub, the township quickly grew into a California poultry powerhouse. The community then gained national attention with Clark's masterpiece, the Norconian Resort Supreme, a breathtaking, 700-acre playground for millionaires and movie stars that ran smack into the Great Depression and laid an egg—perhaps appropriate in the poultry capital of the state.

The community was saved from extinction by the 1941 arrival of the US Navy in the form of a naval hospital. The World War II medical facility took over the old Norconian and quickly grew into one of the finest hospitals in the nation. In 1951, the Navy placed its entire missile research, design, and development lab into the former tuberculosis unit of the hospital. Soon, some of the finest scientists and engineers in the nation were rubbing elbows with local chicken farmers.

The 1950s also brought small-lot developers seeking to put as many cracker-box houses as possible on a piece of land. Norco residents who had begun to establish a significant equestrian community fought ferociously, in a battle dubbed "Houses vs. Horses," to hold off "the carpetbaggers" seeking to cut up the town's large lots. This long battle was won when Norco became a city in 1964, but there were many more fights to come. City council meetings were wild affairs, and residents were quick with a comment and quicker with a recall. But city council after city council held off developers and "folks from Orange County" and managed to preserve huge areas of open space, protect large lots, put a trail on most streets, and become a "city of elbow room."

During its first decade, the City of Norco was a haven for wintering circuses and their menagerie of elephants, giraffes, and high-wire acts; successful poultry operations; and horses. Over time, state laws pushed the circuses and poultry operations out, but Norco still boasts a critter population that includes cows, pigs, llamas, emus, peacocks, sheep, goats, buffaloes, longhorn steers, and, yes, horses.

With the economic downturn in the middle of the first decade of the 2000s, Norco once again remade itself, branding the community "Horsetown USA." The strategy has proven to be a huge boon to the economy; the large lots are in great demand by those wishing to have a little room to breath.

From this history, Norco has produced and fostered an extraordinary number of amazing residents who have gone on to success in every field: sports, entertainment, science, medicine, law, education, and much more. Just as significant, Norco is home to extraordinary people who unceasingly volunteer their time and money to serve seniors, youth sports, schools, and historic preservation. They also create an amazing number of community events.

In the late 1920s, Norco was dubbed "Acres of Neighbors," and while that motto is somewhat forgotten, the legendary locals of Norco, in a very real way, embody that slogan as perhaps the last of a dying breed of citizens who stand up, pitch in, and give a hand to friends and strangers alike.

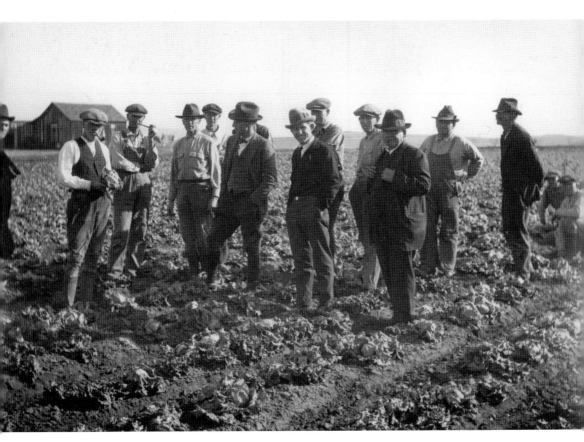

Go-Getters

Rex Clark (center, in profile) envisioned a community where a man could raise a family by living off of his own land. He advertised for folks who "wanted to grab their dreams." Here, Clark stands with "his team of go-getters" in 1922, amid Norco's first major cash crop: lettuce. (Clark.)

CHAPTER ONE

Norco

"Vale of Dreams"

In 1908, a group of entrepreneurs led by James W. Long purchased the land that would one day become Norco: roughly 15 square miles of rocks, tumbleweeds, dry land, alfalfa fields, and several thousand coyotes and jackrabbits. The only other activity was the once-successful granite mines nestled in the rattlesnake-infested foothills to the east; William E. Pedley's "white elephant" power plant, located to the north along the banks of the Santa Ana River; and a cattle ranch or two. On occasion, herds of sheep would pass through to graze, but they did not stay long, as water was scarce. Only the heartiest "hermits," "crazy farmers," field workers, and "the lowest Mexicans" lived in what could only be described as a desolate piece of property prone to flooding, freezes, and the merciless Santa Ana winds.

Nevertheless, Long and his group of financial backers had the idea of creating an agriculture paradise of citrus, walnuts, peaches, and other produce, dubbed "Citrus Belt Farms." Unfortunately, they chose to build on the cheap, putting in inferior water reservoirs and delivery pipes. This made water unreliable, expensive, and tough to get. And the county refused to improve Hamner Avenue, the main road in and out of the community, making access impossible on a regular basis.

Worse, the winds and freezes made growing citrus of any kind on a commercial basis impossible, as well as just about any other cash crop. Nevertheless, Long and his crew attracted residents, primarily by taking prospective investors to view the nearby city of Corona's expansive groves and orchards to the south (just out of reach of freezes and winds) and telling them, quite dishonestly, that the same results could be had in Citrus Belt.

Nevertheless, a few hardy souls did make a go of it as management of the development came and went and despite two desperate community name changes ("Corona Farms" and "Orchard Heights") designed to attract suckers. Residents in this area became well known for their courage, sense of community, and ability to get a "harvest from stones."

By 1920, the stage was set for the entrance of Rex B. Clark: a well-financed entrepreneur who, rather than see rutted dirt roads, frozen trees, and pipes producing mud, envisioned "A Vale of Dreams."

Rex B. Clark

The founder of Norco is virtually forgotten today, except for a ball field and a short street named in his honor. But in his day, Clark was well known in the region and, for a brief moment, across the nation for his construction of a magnificent resort known simultaneously as a "masterpiece" and "Rex's Folly."

Clark's family claimed he always did things big, and, having married into the Scripps newspaper fortune, he could afford to do exactly that. His vision for Norco was not to create a mere suburb of nearby city of Corona, as had been previously planned, but to build a township that stood alone, with a bustling downtown, surrounded by expansive ranches and farms. He envisioned a place where a go-getter could own his own piece of paradise, live off the sweat of his brow, and support a family.

On May 13, 1923, Norco was officially dedicated, but the new township had already established itself as a major California watermelon and lettuce producer; chickens were soon to be the community's ticket to commercial success. A chance discovery of "sweet sulfurized, hot, mineral packed water" derailed Clark's plans to build a "magnificent downtown." Instead, he poured millions into the construction of the Norconian Resort Supreme: a 700-acre resort complete with hotel, dining facilities, Olympic swimming and diving pools, lake, airfield, golf course, and acres of beautifully landscaped grounds.

The stunning playground for the rich and famous opened with a bang on February 2, 1929. But a few months later, both Clark's resort and his community of go-getters walked into the economic buzz saw of the Great Depression.

Worse, Clark divorced and was forced to financially fend for himself—but not for long. The Scripps family was soon to discover that wily Rex had finagled a sizable chunk of the family trust fund away from his ex-wife, Grace. Clark was the first in line for the big 1936 James Scripps Family Trust payout and was back in business, paying off all of his debts and eventually purchasing a large estate in Beverly Hills and a magnificent cattle ranch in Santa Barbara.

Until his death in 1955, Clark, still Norco's largest landowner, refused to sell out "his community" to speculators who wanted to build "cracker box shacks stacked on top of each other." He never let go of his belief that "in America, there must always be that place where 'go-getters' can make a living off the land." (Norco.)

Cuthbert Gully

"Bert" Gully is completely forgotten today, with no marker, park, or street named in his honor. It is a sad oversight, as, very likely, no man did more for Norco's early development than this larger-than-life civil engineer. So much of his work remains.

Gully, a Canadian by birth, was educated in England and immigrated to the United States in 1893. He arrived in the Riverside area the following year and quickly established himself as an engineer of note, particularly in the areas of irrigation, reservoirs, and water-delivery systems. One of his first jobs was to apprentice under famed civil engineer and developer William Pedley and assist in the design of a truly miraculous water-delivery system for the San Jacinto Land Company. The goal was to get water to the future Norco Valley to promote the development of citrus groves on par with nearby Corona. While weather and wind doomed Norco lemons and oranges, Pedley and Gully successfully designed a canal that traveled several miles and delivered plentiful water for the growing of alfalfa, the first truly successful cash crop in the area.

Service in the US Army during the Spanish-American War and World War I led to Gully's nickname, "Cap;" to his friends, he was just plain Bert. In 1909, Gully was hired to lay out the first streets in Citrus Belt and install a "first-class water delivery system." Unfortunately, the developers insisted that Gully use a cheaper, inferior pipe. The captain, "utilizing the colorful language for which he was famous," refused and walked off the job.

When Rex Clark bought most of the community in 1920, his first hire was Gully, at "double his current salary," and the cigar-chomping Canadian, famous for his riding boots and Maxwell convertible automobile, "managed the mess for the next fifty years." Gully was essentially the city manager, responsible for everything from laying out new parcels to repairing roads, installing and replacing water lines, and collecting monies owed.

Rex Clark and Bert Gully became lifelong friends, and it is said that when Norco's founder died in August 1955, the old captain was inconsolable and never quite recovered until his own death in 1963. (Clark.)

Grace Clark (née Scripps)

Rex Clark's wife, Grace, seen here at left visiting Norco, was heir to the Scripps newspaper fortune, and it was she who financed early Norco, the first school, library, and Norconian Resort Supreme. The Clarks divorced in 1930, leaving Rex strapped for cash and Grace, according to her daughter, with a broken heart. She withdrew to La Jolla, married a sea captain and became involved in charitable organizations and the arts. (Clark.)

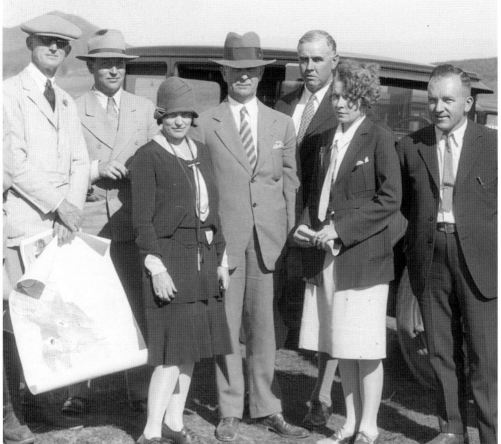

Emma Snyder

Known as "Jimmie," Snyder (third from left) was a shrewd businesswoman who handled Rex Clark's financial interests and also served as his longtime mistress. They married in 1932, following Clark's divorce, and remained together until her husband's death in 1955. She then led a quiet life in Beverly Hills until her passing in 1979. It is unknown what happened to the Clark fortune following her death. (Clark.)

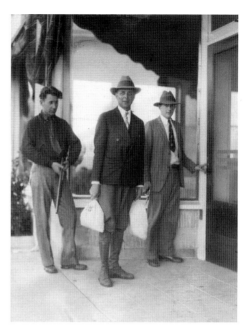

Frank Hitchcock

Hitchcock (center) was the managing director of the North Corona Land Company, as well as salesman, spokesman, and paymaster. He was also charged with transporting cash for payroll. Escorted by two armed guards, Hitchcock and a cadre of police cars created quite a stir as they raced along Hamner Avenue between the bank and Norco with sirens blazing. Hitchcock received the first shave in Norco's first barbershop. (USC.)

R.E. Chadwick

Chadwick, seen here on the left with an unidentified salesman, was the sales manager for Clark's development operation, the North Corona Land Company. "Chad" devised a marketing plan that culminated with prospective "wined and dined Los Angeles buyers" being transported to Norco to view "parcels of paradise." Chadwick's wife, Sarah, started Norco's first newspaper, the *Beacon*. Chad was a serious conservative who later wrote a controversial column for the *Corona Daily Independent*. (Clark.)

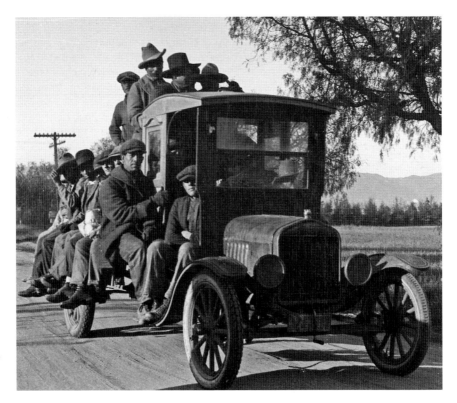

Epamuscemo Ramirez

Beginning with the Citrus Belt construction in 1909 and throughout the early development of Norco, Mexican laborers, for pennies a day, were used to do the grunt work: digging ditches, building and repairing roads, planting fields, and constructing water reservoirs and pipes. However, men of color, whether Hispanic, black, or Asian, were precluded from owning a home in Norco. The best they could hope for was the North Corona Land Company's "Mexican bunkhouse" or a shack on the ranch that employed them.

Most of these laborers lived in Corona, in an area specifically segregated for Mexicans. This was an era of great flux for many Hispanics, who followed the growing seasons and moved from place to place to harvest crops. Norco's first 10 years was a time when "the Mexican problem" was widely editorialized and just about any crime sent law enforcement into the Corona Barrio as the first brutal stop to find the culprit.

Rex Clark no doubt held racist views, and it was an era when Hispanic labor was not normally given supervisor duties over whites. But, the founder of Norco nevertheless placed Mexicans in several positions of authority. Delano Ramirez was in charge of the cement plant, and Bill Lemus commanded a road crew and served as the company electrician. It was Lemus who showed Rex Clark the hot springs upon which the Norconian resort was founded.

Epamuscemo Ramirez worked for Clark for over 20 years, beginning as a laborer, then supervisor, Norconian resort groundskeeper, and finally "keeper of the hot springs." He is seen here driving a group of laborers to Norco.

During one very distasteful event, when Ramirez was wrongly accused of a crime, Rex Clark and Captain Gully both stood up for their employee in court, stating, "Mr. Ramirez is the finest Mexican we have ever known." The judge let him go. Ramirez's son Augustine went on to become the first Hispanic superintendent of the Corona–Norco Unified School District.

In the end, what cannot be taken away is that Hispanic labor played a key role in the development of early Norco. That fact should not be forgotten. (Clark.)

Dale Rycraft

Rycraft served as superintendent of Norco's community-owned Orange Heights Water Company and was considered one of the "best water men in the state." This respect saved his life when, in a fit of jealousy, he "accidently" poisoned his wife and himself with cyanide. She died, but he lived to face manslaughter charges. Letters from powerful friends allowed Rycraft to walk free with five years' probation. (Clark.)

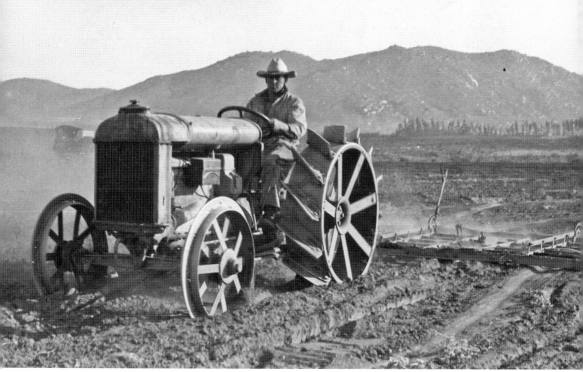

Cal Warner

Famed as the "best-known bean thresher in the area," Warner served as the *zanjero*, or "ditchrider," patrolling Norco's irrigation ditches to keep them in repair. Warner's true fame was as a shortstop for the North Corona Land Company's baseball team, the Coyotes. He later stated, "Our team was dismal until fellas from everywhere came to build the Norconian; they could flat play ball and we were unbeatable." (Clark.)

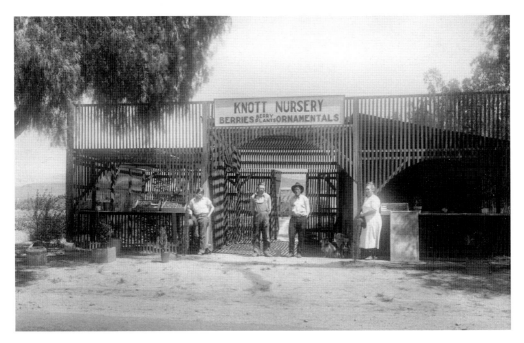

Walter Knott

The berry farmer (second from right) arrived in Norco with a plan to "develop the greatest berry country in America." He planted 10 acres and opened a fruit stand, selling produce, poultry, and rabbit meat. Knott claimed that poultry manure and plentiful water were key to growing berries. Droppings were plentiful, but water was problematic. Knott sold out to focus on chicken dinners in Buena Park, and the rest is history. (OCA.)

Rex Scripps Clark

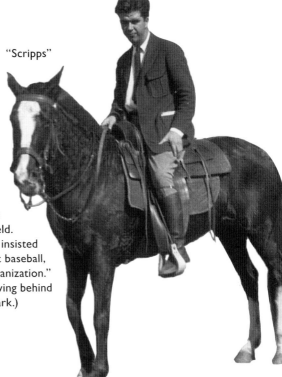

Frequently confused with his famous father, "Scripps" nevertheless played a significant role in Norco's early development. A graduate of Caltech, he became the managing director of the North Corona Land Company in 1922 and quickly proved wrong those who felt someone "with a silver spoon in his mouth" and so young could "never cut it." Scripps was quick to care for injured workers, active in the community, wore authority quietly, managed the company baseball team, and served as Norco's first postmaster. He successfully brokered with the Riverside County supervisors in 1924 to improve Hamner Avenue, and he laid out Norco's first ball field. Cal Warner later remembered, "Rex, the son that is, insisted on a first name basis, was very knowledgeable about baseball, was very kind, fair to the employees," and a "whiz at organization." Scripps Clark was also a whiz as a photographer, leaving behind hundreds of photographs depicting early Norco. (Clark.)

CHAPTER TWO

What's in a Name?

Norco is home to many parks, streets, rocks, buildings, plaques, and hills that bear names and nicknames of both well-known and forgotten persons.

The community from the beginning has sought to honor those residents who have done the extraordinary, were lost to tragedy at an early age, performed great service to the community, died in political office, or were killed in service to the country during wartime. For a historically small, rural community, Norco has had its share of heroes, great men and women, and tragic losses.

In some cases, streets and other landmarks were named to honor one's heritage or a special activity or event. Sierra Avenue was named to honor Grace Clark's status as a founding member of the Sierra Club, and Detroit Street was so named to honor Rex Clark's hometown and to establish that this was the community's "bustling hub of commerce." The Norco Hills along the eastern edge of the community were once known as La Sierra. Loosely translated from Spanish, this means "Sawtoothed mountain range," an appropriate name. To the right of this ridge is a large rocky hill known for many years as Rattlesnake Mountain, due to the still huge population of poisonous snakes. Running from the north and along the east border of Norco is the Rio de Santa Ana, or Santa Ana River. Named in 1769 by the Gaspar de Portola expedition, likely to honor St. Anne's Day, this is the largest river running entirely in Southern California.

Throughout Norco, there are all kinds of little plaques and memorials: a small bronze memorial dedicated to equestrian Ben Weaver, husband of Nellie Weaver, can be found at Ingalls Park. In a churchyard sits another bronze work dedicated to Norconians who died in World War II, and there is a plaque on a rock in the Norco Hills dedicating the Stringfellow Granite Works dating to the 1930s. And there are plaques that are no more—two in particular that were attached to trees have since been removed.

The following pages highlight heroes, extraordinary volunteers, and nicknames.

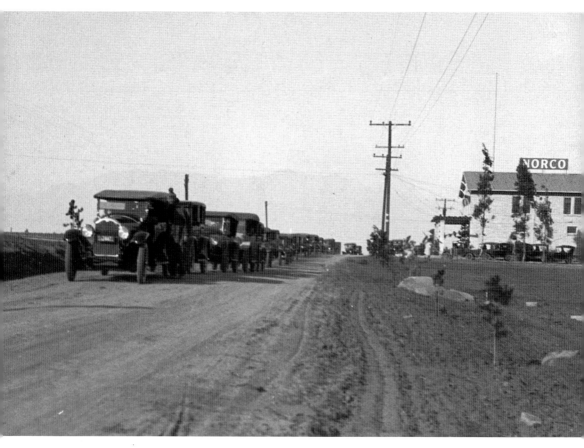

Norco

Between 1909 and 1923, future Norco, seen here on Christmas Day,1925, was known as Citrus Belt, Corona Farms, and, finally, Orchard Heights. This last name was the result of a Corona Chamber of Commerce contest designed to rename and hopefully rejuvenate the struggling community.

Rex B. Clark's son Rex Scripps Clark is credited for renaming the community Norco. Most people assume the name is simply a contraction of "North Corona," prompted by the town's proximity to its neighbor to the south. This is partially correct, but there is a more interesting story behind the name. Baseball was hugely popular in the area, and most companies had teams. Thousands of spectators would crowd around to watch the highly competitive games, the results of which were front-page news. Representing the Orchard Heights community and Clark's development company was the North Corona Land Company Coyotes, managed by none other than Rex Scripps Clark. In October 1922, the *Corona Daily Independent*, perhaps to save a little newsprint space, contracted the team name to "Nor Co Coyotes."

Rex S. Clark went to his father and suggested that "Norco" was a pretty good name for a town, and Rex B. Clark agreed. So, on May 13, 1923, the township of Norco was born. The community was named after a last-place baseball team. It must be added that Clark apparently did not care to lose, and by 1925, with the aid of professional ballplayers, the Coyotes became unbeatable. (Clark.)

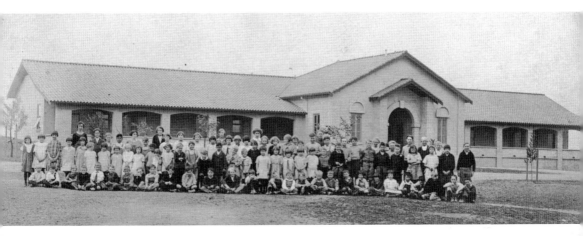

Florence Smith Library

In 1930, the Florence Smith Library opened. It was the first known facility in Norco to bear a resident's name. Smith (second row, far left), a teacher, was killed in an automobile accident, and it was her personal collection of books upon which the library was founded. This photograph was taken on opening day, January 5, 1925, in front of the brand-new Norco School.

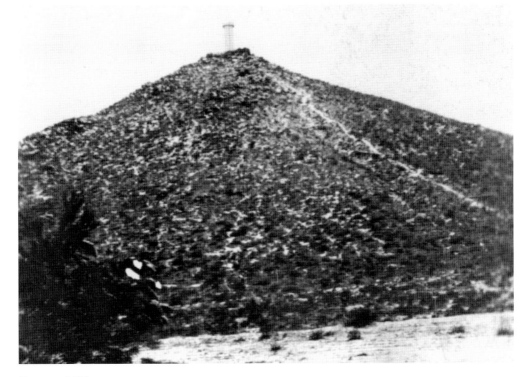

Beacon Hill

This prominent landmark was once known as "Chocolate Drop," because of its resemblance to the Hershey's candy. This changed in 1923, when founder Rex Clark placed a beacon atop the hill that resembled a lighthouse. The initial purpose was to attract customers to his new community, but eventually, this landmark, visible at night for miles, became an important component to the national airmail system and aviation in general. (Norco.)

Clark Avenue and Clark Field
The street in front of Norco City Hall, and one of Norco's busiest ball fields, were named in honor of Norco's founder, Rex B. Clark. The land for the baseball diamond was donated by Clark's second wife, Jimmie, and was originally intended for use as a fire station, then as a local refuse dump. A group of volunteers built the popular playing field in the late 1960s. (USC.)

John Thomas Hamner Avenue
Hamner, seen here with his wife, Mattie, was a well-respected businessman and rancher. He pioneered the area's first telephone company and, as county supervisor in 1907, funded the first improvements to the avenue that would bear his name. Hamner's daughter Luellen eventually became a teacher at the Norco School, and her pupils were fascinated with the idea that the road right outside their window was named after her family. (UCR.)

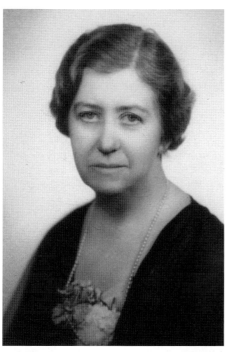

Mrs. Clark's Roses

In 1925, Grace Clark planted old garden rose bushes around Norco School. These ancient roses were lovingly protected, and children were cautioned to take care around "Mrs. Clark's Roses." The roses were transplanted to Sierra Vista Elementary in 1949, and eventually, there were dozens of gorgeous plants. Sadly, a new groundskeeper, weary of caring for the prickly plants and not understanding their value, tore them out.

Pedley Avenue and Power Plant

English civil engineer, cricketer, founder of Pedley, California, and polo enthusiast William E. Pedley built Norco's oldest building, the abandoned Riverside Power Company power plant. Captain Gully named Pedley Avenue in his mentor's honor. At the end of the avenue was once a simple, undeveloped field (today the site of homes) used extensively by equestrians and known as "Pedley Field." (Ruth McCormick.)

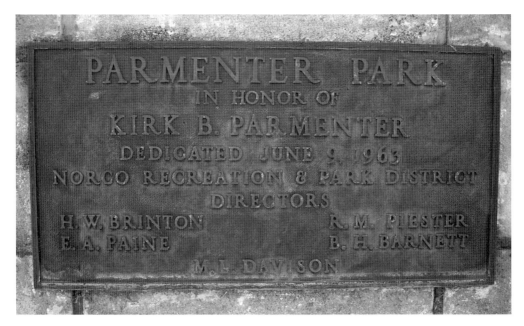

Kirk Parmenter Park

Known as "Mr. Norco," Kirk Parmenter served as "an unpaid volunteer" with the chamber of commerce, the Norco Recreation and Park District, the Norco Fair Committee, Community Services District, and several service clubs. He organized the construction of the first public pool and the ballpark that would bear his name. When Parmenter Park was dedicated on June 9, 1963, he was visibly shaken and wept. (Norco.)

Jerry Riley Gymnasium

Mayor Riley died in office on July 17, 1977. Prior to his council tenure, he was a founding member of Equestrian Trails, Inc., Corral 32, and served on the park commission that would eventually construct the gym that would bear his name. Riley successfully advocated for Norco's first designated trails and was a driving force behind the development of Ingalls Equestrian Park. (Norco.)

Neal Snipes Park

Corporal Snipes is believed to be the first Norconian killed in action. Neal moved with his family to Norco in 1932 and began school at Norco Elementary, where he quickly earned a reputation as both a gifted athlete and scholar. He made the varsity baseball team in the eighth grade, earned letters in five sports, and gained a spot on the 1938 Helms Athletic Foundation First Team All Southern California football squad before graduating in 1940 from Corona High. His exploits on the football field and baseball diamond were regularly chronicled in area newspapers. Snipes excelled in academics, sang with the choir and glee club, was active in his church, and by all accounts was highly regarded by the community. After playing for a year at Long Beach City College under legendary Jess Hill, his former high school coach, Snipes joined the Marine Corps on January 9, 1942. As a member of the 2nd Marines, he survived the Battle of Guadalcanal but was killed on the first day of the Battle of Tarawa, November 20, 1943.

A concerted campaign by boyhood friends led to the dedication of Neal Snipes Park on November 4, 1971. USC athletic director Jess Hill, the keynote speaker at the park's dedication, broke down as he spoke of Snipes. Phil Newhouse, Snipes's best friend and himself a decorated war hero, stated: "He did it all, I call him an athlete's athlete. If he hadn't been killed, he would've been a pro baller because of his athletic abilities."

Sadly, Neal Snipes's mother never recovered from the death of her son, and a close family friend later said, "Neal's mom died of a broken heart, just plain and simple, a broken heart." (Phil Newhouse.)

Nellie Weaver Hall
In 1970, outspoken Nellie Weaver, seen here with her husband, Ben, became the first woman elected to the Norco City Council. Prior to that, she was an active member of the Norco Incorporation Committee and, when cityhood was achieved, worked for the cash-strapped city as a clerk and secretary for three months without pay. Eventually, Nellie was hired as Norco's first employee and eventually became deputy city clerk.

Ted Brooks Park
Brooks arrived in Norco in 1943 and served the community water company. He worked his way up from general employee, servicing the system of Norco well pumps, to maintenance foreman. The park was originally designed to serve as part of a planned chain of equestrian stops along the Coast to Crest Trail that extended from the mountains to the Pacific Ocean. (Becky Mendoza.)

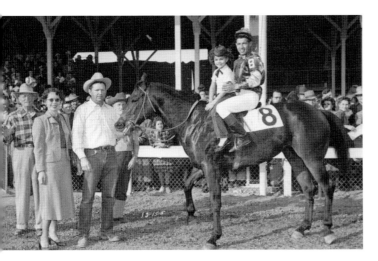

Eddie Moreno Memorial Arena

Known affectionately as "Pardo," Eddie (on horse with his daughter Mary) was a top California jockey, winning the first legalized quarter-horse race in the state at Bay Meadows in October 1949. However, it was his skill as a trainer and an all-around horseman, and his willingness to share "his gift," that prompted residents to memorialize his name on Norco's most prized equestrian arena. (Mary Hall.)

Wayne Makin Park

A complex of five ball fields was named to remember 13-year-old Wayne Makin (second row, far right), who collapsed and died while playing basketball. It was dedicated on March 30, 1974. Makin was a seventh-grade honor student who excelled at sports, particularly baseball, basketball, and bowling. This park was actually the second Wayne Makin Field; the first was demolished for a housing tract. (Bonnie Miller.)

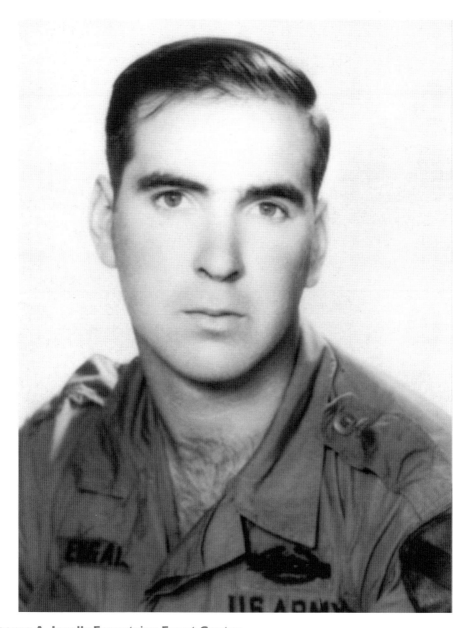

George A. Ingalls Equestrian Event Center

A young man who grew up in an era when Norconians attended Corona High School, George Ingalls was quiet, unassuming, excelled at sports and academics, and was immensely popular with his fellow students, who voted him "Mr. Lucky" in his senior year.

He enlisted in the Army in 1966 and was deployed to Vietnam, where he sacrificed his life to save members of his unit. He received a posthumous Medal of Honor. George's mother, Maude Ingalls, dedicated the event center on January 19, 1974.

The Norco High School Air Force Junior ROTC named its headquarters in his honor. Each year, the organization awards the substantial George A. Ingalls Memorial Scholarship to the college-bound cadet deemed most outstanding in his or her senior class.

The City of Norco has officially declared April 16 to be George Ingalls Day.

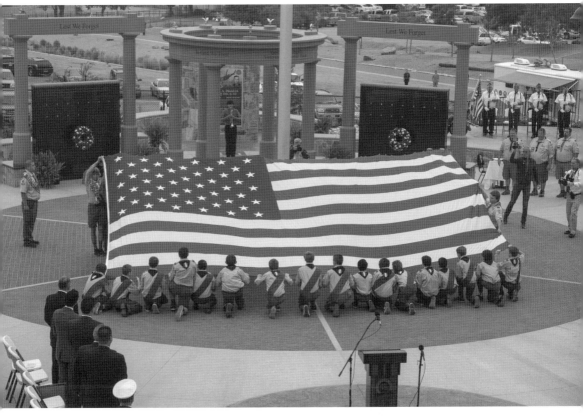

George A. Ingalls Veterans Memorial Plaza

In 2014, Mayor Berwin Hanna presided over the celebration of Norco's 50th anniversary of incorporation. To commemorate the event, a Wall of Honor listing those Norconians serving in the military who died in action, in service, or due to deaths after combat as a result of grievous injuries or illnesses was planned. Public support and donations exceeded all expectations, and the simple wall grew to become a plaza, complete with arena seating and a rotunda covering half an acre. The plaza includes a Court of Honor, where any and all veterans can have their names inscribed on bricks. The memorial was dedicated on Veteran's Day, November 11, 2014, with 3,000 people in attendance.

The Wall of Honor includes the following persons (with their place and year of death): Cpl. Neal E. Snipes, US Marine Corps, Tarawa, 1943; Sgt. Clyde E. Agee, US Marine Corps, Iwo Jima, 1945; Pvt. James M. Garner, US Army, 1941; Pfc. Medic William R. Locke Jr., US Army, Okinawa, 1945; Cpl. Robert E. Greer, US Marine Corps, Marshall Islands, 1944; Avn. Cadet Thomas B. Smith, US Army Air Corps, Texas, 1942; Lt. Thomas B. McKiernan Jr., US Army Air Corps, Norco, 1957; WO Timothy J. McKiernan, US Army, Vietnam, 1968 (Posthumous, Distinguished Flying Cross, Heroism); WO Eric Claude McCorkell, US Marine Corps, North Carolina, 1963; Cpl. Wilburn Monroe J. Goodman, US Marine Corps, Korea, 1952; Pfc. Charles J. Rutledge, US Army, Korea, 1951; F3c. William C. Fick, US Navy, Camp Pendleton, Korea, 1953; MM Fireman Herold T. Deardorff, US Navy, Vietnam, 1966; Pfc. Steven J. Wright, US Marine Corps, Vietnam, 1967; Pvt. Richard O. LaCasse, US Marine Corps, San Diego, 1968; Amn. David Deatherage, US Air Force, Japan, 1962; Pfc. Clyde D. McDonald II, US Marine Corps, Vietnam, 1966; Sgt. Billy Wayne Phillips, US Army, Corona, 1998; Spc. Peter R. Schneider, US Army, Corona, 2007; Pfc. Adam T. Hoage, US Marine Corps, Iraq, 1991; Sgt. Ryan C. Young, US Army, Walter Reed Hospital, 2003; Gy. Sgt. Emmitt J. Wilkey Jr., US Marine Corps, Vietnam, 1966; Capt. James B. Evans, US Army, Lytle Creek, 1980; Spc. George A. Ingalls, US Army, Vietnam, 1967; and Gy. Sgt. Emmitt James Wilkey Jr., US Marine Corps, Vietnam, 1966. (Richard Fields.)

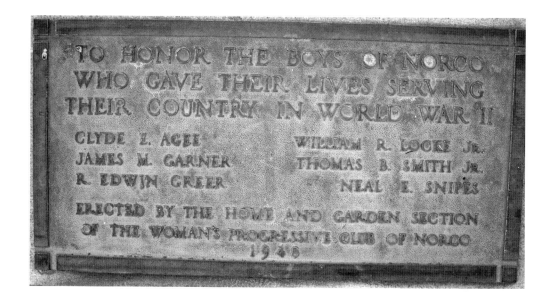

Forgotten Legendary Locals

Throughout Norco, there are numerous bronze plaques commemorating forgotten people and events. On the Norco naval base is a stone remembering the old hospital; in a church courtyard is a plaque listing young men who died in World War II (above); in a park near a tree is a small plaque remembering a loved equestrian; nearby, another plaque remembers a longtime volunteer; at another park, a bronze depicts Norco girls' softball hall of famers; and in front of the American Legion is a pillar with names of those members now gone. The Norco Valley Fair, the longest-running all-volunteer fair in California, is remembered on a stone (below). A bridge at Norco High honors a former principal, and at the local library are chairs with small plaques bearing the names of generous patrons.

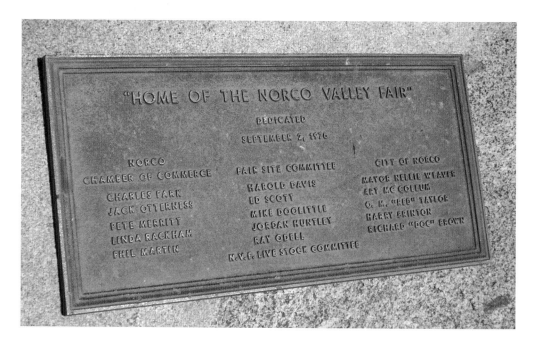

Deputy James B. Evans Memorial
At Norco City Hall, a memorial honors the community's only law enforcement officer lost in the line of duty. Deputy Sheriff James Evans was shot and killed during the infamous Norco Bank Robbery on May 9, 1980. Evans was a highly decorated veteran of the Vietnam War. At the time of his death, he served as a captain in the US Army Reserves. (Mrs. James Evans.)

Sergeant Gilbert Cortez and K-9 Mattie Memorial Highway
Located on the stretch of the Interstate 15 Freeway that runs through Norco, the highway memorializes Norco High graduate Cortez, a respected and much-loved sergeant at the California Rehabilitation Center in Norco, and his narcotics dog Mattie, a Belgian Malinois. Both were killed in an automobile accident while performing their duties on March 25, 2013. (California Rehabilitation Center.)

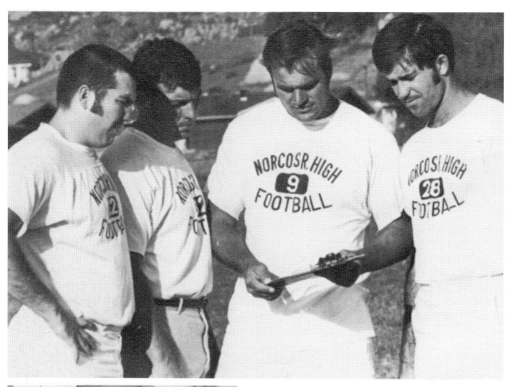

Gary Campbell Field

On November 23, 2009, the Norco High football field was named in honor of Gary Campbell (second from right), who served 34 years as head coach. Campbell's teams won 279 games (seventh on the all-time list for California high schools), 3 Interscholastic Federation Southern Division titles, and 11 league titles, and he was named Coach of the Year six times by the Riverside County *Press Enterprise*. (NHS.)

Don Harris Field

Harris coached baseball at Norco High School for over two decades and served a long stint as athletic director. Of his players, 70 went on to join college teams, and four made the major leagues (Mike Darr Sr., Curt Wardle, Kevin Olsen, and Darryl Kile). His career record was 303-272, and his teams won seven league titles. (NHS.)

William T. Vaughan Memorial and Street

Bill Vaughan advocated for business to generate city income, rather than taxes. A strong member of the chamber of commerce for decades, Vaughan ran unsuccessfully for council twice, but the "third time was the charm." His views on motorcycles and lot sizes frequently pitted Vaughan against equestrians, but he was considered fair. He was instrumental in modernizing Norco's water system. (Corona.)

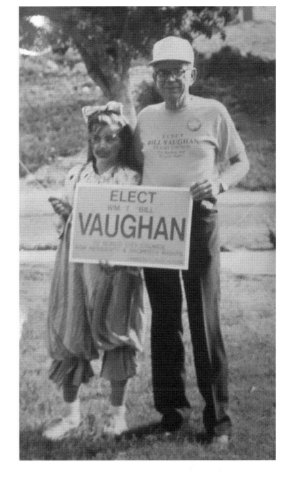

Malcolm Miller Trail

Miller died while serving as Norco's first black mayor in 2010. Highly cultured, intellectual, and articulate, Dr. Miller earned a medical degree from the University of Cape Town in South Africa, became a naturalized US citizen, practiced as an anesthesiologist, and taught at Harvard Medical School. An avid horseman, Miller was a strong advocate for Norco's equestrian lifestyle. (Brigitte Jouxtel.)

31

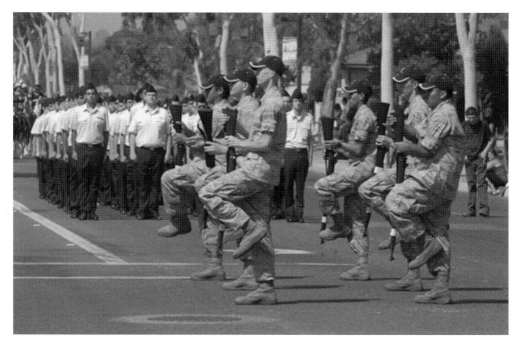

George A. Ingalls Memorial AFJROTC

Norco High's Air Force Junior Reserve Officer Training Corps (AFJROTC) dedicated its corps to Medal of Honor recipient George Ingalls. Beginning with a handful of "ragtag" cadets in 2005, this unit has grown to hundreds of current and past members and produced several stellar graduates who have gone on to top college ROTC programs, military careers, and academies. Well known and appreciated for its active community service, the corps today is commanded by Maj. Brian "Cowboy" Clark, USAF (Ret.).

There is likely no youth organization more actively engaged in community service than this stellar group of young men and women. Here, the award-winning Rifle Drill Team performs during the annual Norco Fair Parade.

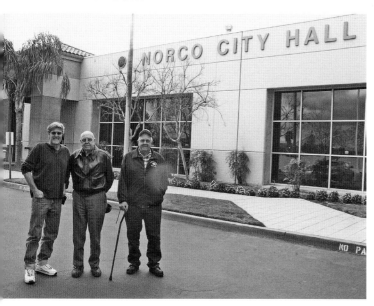

Robert Peister

"Bob" (right)will be found on several plaques throughout Norco. Serving as the facilities director of local school district and parks trustee, he built several schools and Norco's first lighted ball field. He retired to become a farmer: his "dream job." His brother "Gene" (center), pictured with Kevin Bash (left), is in his 90s, still works and drives, is active in the community; he is believed to be the oldest living Norconian. During World War II, Gene was a member of the famed "Air Commandos," who fought in Burma.

Louis VanderMolen Drive

Louis VanderMolen (right) died at the age of 96, following a lifetime of community service. VanderMolen fought in the Dutch resistance in World War II and, after being captured by the Nazis, was rescued with a bribe of butter by his future wife, Ada. The two emigrated from Holland to America in 1951, and VanderMolen worked in the dairy business and as a cabinetmaker, eventually opening a successful hardware store at his own VanderMolen Center. As president of the Norco Chamber of Commerce, a founding member of the Norco Kiwanis, a church deacon and trustee, and a longtime school board member, VanderMolen became a well-known and distinguished figure throughout Norco and surrounding communities. His endorsement was much sought after by politicians seeking to win elections.

It was the "tall Dutchman" who pushed to change the name of the district to include "Norco" (Corona-Norco Unified School District) and to develop more comprehensive manual-arts programs in the high schools. He was a man who put children first and was not afraid to voice his opinions or bend the rules to circumvent "useless bureaucracies." Widely respected as a pillar of the education community, VanderMolen received many awards for his volunteerism. The Corona-Norco Unified School District named in his honor the Louis VanderMolen Fundamental Elementary School, located in the nearby community of Jurupa Valley.

One cannot mention Louis's accomplishments without including his wife, Ada. She was his partner for well over 50 years and a force to be reckoned with in her own right. (Corona.)

Dave Cummings Field
Located at Wayne Makin Park, this ball field was named in honor of longtime Little League coach George "Dave" Cummings. A quiet, humble, unassuming man, he spent countless hours patiently teaching children the sport he loved: baseball. He refused to engage in politics, seldom lost his composure, would give the shirt off his back to anyone who asked, and "put the kids first." (Cara McCray.)

Hal Clark Arena
Located at the George Ingalls Equestrian Event Center, this covered arena was named for one of the community's most popular residents. Among his accomplishments, Clark was a founding member of the Norco Animal Rescue Team and of Horseweek. He was a very popular city councilman and former mayor at the time of his death. Hal Clark was an outspoken advocate for a rural lifestyle and for youth activities of all sorts. (Norco.)

34

Mildred Whiteside Fluetsch Plaque
The Norco Community Center, once the Norco School (1925–1947), bears a plaque paid for by former students dedicated to a truly remarkable educator. Much-loved Mildred Fluetsch began as a teacher at Norco School in 1933 and moved quickly into the role of principal. She oversaw the transition in 1949 to the new Sierra Vista Elementary School while doing double duty as the Eastvale School principal. (Corona.)

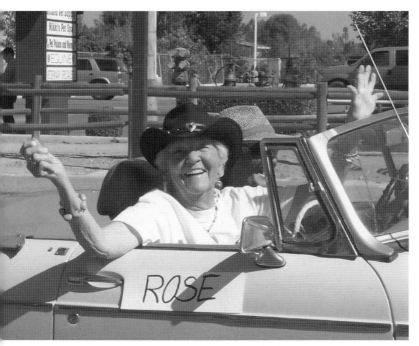

Rose M. Eldridge Senior Center
A proud Oklahoma migrant, Rose settled in Norco in 1965 and set volunteer standards that have prompted comparisons to saints. A fierce fighter for those she describes as "my seniors," Eldridge supplied food, transportation, access, and information to "those who need a hand." Now approaching 100 years of age, Eldridge is one of Norco's most esteemed citizens. (Barbara Hill.)

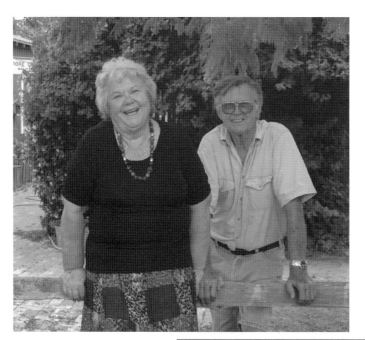

Bob and Karlene Allen Room

Bob Allen arrived in Norco as a naval hospital corpsman. After suffering injuries at the Battle of Peleiu, he returned to "marry Karlene." Karlene moved to Norco at seven and still lives in her childhood home, known affectionately as the "Christmas Tree Farm," though that enterprise closed many years ago. Bob recently passed, but the Allens' charitable work lives on and is truly legendary. (Brigitte Jouxtel.)

Sharon Martinez Performing Arts Auditorium

The Norco High School auditorium is named in honor of longtime Corona-Norco School Board trustee Martinez, described as "a champion for children." She was a tireless volunteer with the American Youth Soccer Organization and the Parent Teacher Association and an outspoken advocate "for the kids." In great pain toward the end of her tenure, Martinez never allowed her illness to compromise her passion for education.

Victress Bower School

This wonderful school was named for a teacher from the early 1900s who willed funds to be specifically used for children with special needs. Per the 1975 federal mandate "to assure a free appropriate public education to all children with disabilities," the task was given to the extraordinary educator John Aldrian, who in turn created one of the finest special-needs schools in the nation. (Victress Bower School.)

Pumpkin Rock

Atop the La Sierra ridgeline sits "Pumpkin Rock." However, this large boulder was known for decades as "Elephant butt," due to a black lightning streak down the center. In the early 1900s, this rock was nearly quarried for granite, but it received a reprieve when workers realized it provided shade. Graffiti prompted residents to "clean up the eyesore" with orange paint, and "Pumpkin Rock" was born.

Greg and Peggy Shearer Field

This park was a community effort of love and hard work. Greg and Peggy Shearer galvanized American Youth Soccer Organization Region 37, the Amateur Athletic Foundation, and countless volunteers to literally convert a huge hole into children's soccer fields. Pictured is the Shearer family during the grand opening on September 29, 1990. Sadly, Greg Shearer did not live to see the park named in his family's honor. (Peggy Shearer.)

Quinn McEgan Field

In 1997, wearing his Braves uniform, 15-year-old Quinn died in an automobile accident on his way to the ballpark. Full of athletic promise, determination, and a serious work ethic, the young ballplayer had just led his team to the league championship and played on the USA team at the Pan-American Games. Quinn McEgan Field was dedicated in July 1997. (Lou Rivera.)

Robert Samsoe Field

Robert, seen here with his wife, Charley Samsoe, served as a devoted softball coach, board member, and father who touched dozens of young athletes' lives. He was famed for his will to win, booming voice, and care for players. When he passed away suddenly during the 2015 season, a truly inspiring memorial, packed with players old and new, parents, and friends, was held to remember this wonderful bear of a man. (Charley Samsoe.)

Rex and Pat Cooter Field

Tiny Pat Cooter (pictured) has taught hundreds of girls to hit, pitch, and field on the Norco softball diamonds that her husband, Rex, and she helped to build. Pat began playing fast-pitch after arriving in Norco in 1968 and coaching shortly thereafter. She created a five-decade legacy of players she inspired and taught how to live right through the simple game of softball.

Brenda and William Davis Center for Student Success
Dr. Brenda Davis was Norco College's founding provost, eventually the first president, and key to its growth from a small branch campus to a full-fledged and award-winning community college. Physician William Davis worked tirelessly with his wife, campaigning to bring millions of dollars in construction funds to the college. (Brigitte Jouxtel.)

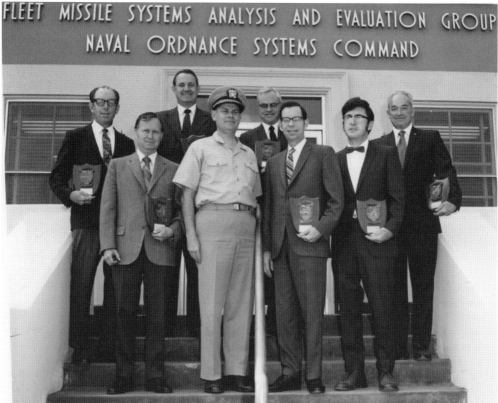

Aaron B. Powers Bell
Dedicated at Norco's Navy base on June 29, 1973, the bell honors the Fleet Missile Systems Analysis and Evaluations Group's first technical director, Aaron B. Powers (front, second from right). Powers bucked a powerful Navy bureaucracy, defense contractors, and a sitting congressman to expose malfunctioning missile systems and establish the Navy's first quality-control organization to "ensure weapons work properly when those in harm's way need them."

CHAPTER THREE

Heroes, Leaders, Teachers, and Preachers

For a relatively small town, Norco has produced not a few extraordinary people who have had great impacts in all walks of life: business, law enforcement, politics, medicine, religion, management, and education, to name a few. This creates the difficult task of selecting a limited number of significant people for a book with only so many pages. And sometimes, as in the case of the wonderful Mark Moore, a deserving person is absent because their desire to be anonymous intercedes.

It was difficult not to include the inspiring Dr. Kent Bechler, who steered the local school district through very tough financial times and came out the other side with one of the best education systems in the nation. What of the number of amazing teachers who work in Norco schools? There are literally hundreds who could fill several books. There is current superintendent Dr. Michael Lin, who continues to take the district to new levels.

What of the men of faith who have carried the Gospel to Norconians for almost 100 years? Rev. Clarence Van Heukelom steered Church on the Hill. Rev. Atlee Bahler of the Community Church of Norco and Sr. Hilda Gelegan, first full-time principal of St. Mel's Catholic Church School, were widely respected in their day.

Then there are the businesspeople who not only made a dollar or two but also gave back to the community over and over again: Harry Brinton, Rob Koziel, Jim and Monique Crain, Dr. Jesus Martinez, Pam Smith, Dr. Ami Shah, and others too numerous to count.

Dr. John Koning, who served on the first city council, was a driving force behind Norco becoming a city in 1964. He orchestrated a truly masterful campaign to stop neighboring communities from annexing huge swaths of Norco land and developers bent on building hundreds of cracker-box homes in the rural countryside.

Finally, through the years, there have been many gifted township and city employees. City managers of note include Norco's first, Sam Kalfayan, and Nick Poppelreiter, George Lambert, Beth Groves, and Jeff Allred. Animal-control officers Mickey Kulick, Renee Power, and Chuck Hemmings brought the department into modern times. Bill Thompson created one of the outstanding water systems in the state, and parks and recreation director Ray O'Dell broke new ground with his innovative program planning and care for the community.

Thank you to all of the wonderful people who have made and continue to make Norco an outstanding place to live.

John Zickefoose

"Mr. Z" serves as the first designated Norco-area trustee for the Corona-Norco Unified School District. His story of battling his inability to read in adulthood is inspirational; today, he is a tireless advocate for literacy. Zickefoose, familiar to literally thousands of children, is an animated storyteller whose passion for reading and unique voice are in great demand. (Brigitte Jouxtel.)

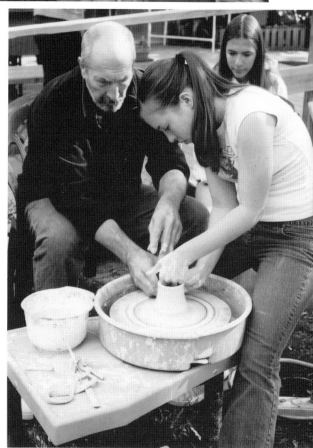

Jerry Smith

A lifetime Norconian, Smith, an outstanding high school, college, and professional athlete, served as "a respected teacher's teacher" at Norco High School for over 40 years. He began in physical education, serving as a baseball and basketball coach, and he taught arts and crafts. A colleague stated: "Jerry did not just teach ceramics. Through clay, he taught life lessons and changed the destinies of hundreds of kids." (Smith family.)

Roy Gladwell
This remarkable and humble man has overseen more than 800 Eagle Scout projects since the early 1980s, sometimes interviewing the sons of men he had previously awarded Boy Scouts' highest honor. Gladwell, with his distinct handlebar mustache, has served as Scoutmaster and on the California Inland Empire Council and is a recipient of Scouting's highest adult-leader award: the Silver Beaver.

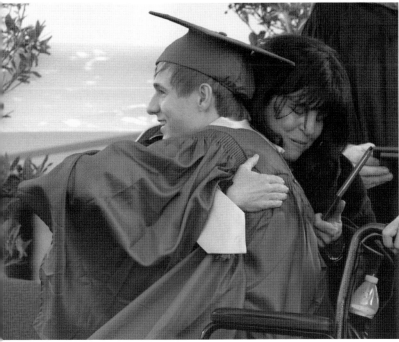

Lisa Simon
After serving in several capacities in the Corona-Norco Unified School District, Dr. Simon took the reins of Norco High School in 2010. With an outstanding staff of administrators and teachers, she improved test scores and graduation rates and earned the honor of Administrator of the Year from the Association of California School Administrators. Today, Dr. Simon serves as assistant superintendent of educational services. (Gary Evans.)

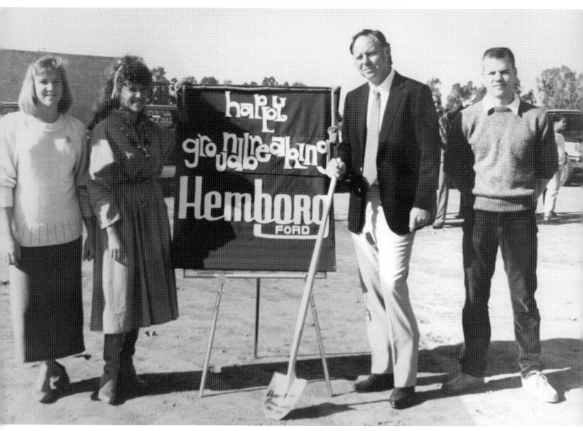

Bob Hemborg

In 1987, Hemborg Ford was the first new car dealership to take a chance on doing business in Norco. Bob Hemborg (with shovel) began as a dealership lot boy, running errands. He is widely known for his business acumen, community involvement, and charitable contributions. Today, his son Tor (right) is the general manager; his semiretired father still keeps a hand in the very successful dealership. (Bob Hemborg.)

Howard Hanzlik

Representing a syndicate of Hawaiian investors, Hanzlik purchased 1,500 acres from Rex Clark's widow in 1958 with the intent of developing small-lot residential properties. Frustrated by heavy opposition, he sold off a portion of the land to a developer who constructed the first equestrian-oriented residential area in 1970. Hanzlik stated later, "The idea was laughable at the time, but, it took off like wildfire." (Michael Hanzlik.)

Eva Wallace

Known as the "Godmother" of both the Norco Chamber of Commerce and American Legion Auxiliary for her service in the 1950s and 1960s, Wallace's greatest contribution was as staff writer for the *Corona Daily Independent*. She produced the "Norco News" and hundreds of articles detailing community events. Like Norco reporters before her, Wallace, seen here with her brother-in-law Rudolph, worked from home and provided an astonishing amount of information to Norco readers. (Wallace family.)

Ed and Linda Dixon

Passion, dedication, commitment to community, and outspoken honesty personify these Norconians. Ed is involved in numerous organizations, including the Norco Animal Rescue Team and Norco Horseman's Association, and Linda is equally active in a number of committees and most prominently in the Lake Norconian Club Foundation. Both are known for their common sense and are sought after for their skills as bookkeepers and treasurers. (Dixon family.)

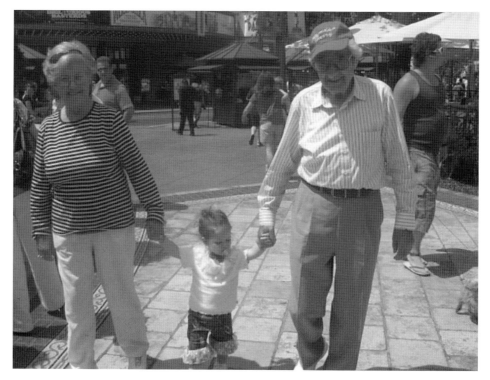

Harry and Hilda Eisen

Polish Holocaust survivors Harry Eisen and his wife, Hilda, arrived in the United States in 1948 with 99¢ and speaking no English. Raising money by cleaning out meat barrels at a hot-dog factory, Harry Eisen purchased his first 100 chickens and, from an Arcadia, California, backyard, launched a neighborhood egg-peddling business that would become one of the largest egg-distribution companies in the world. His company shipped Norco Ranch eggs across the United States and around the globe and fed millions of men and women in military service.

The Eisens moved to Norco in 1952, becoming extremely patriotic American citizens in 1953. Beginning with 1,000 chickens, they worked seven days a week, 20 hours a day, and, working with their children, built an empire that eventually boasted a workforce of 500 employees. The company had a population of almost one million chickens spread out over several ranches and produced over two million eggs a week.

The number 144492 was tattooed on Harry Eisen's left arm—a horrible reminder of his four and a half years of imprisonment at Auschwitz and forced labor as a coal miner at a Nazi death camp. When it became clear he was to be murdered by the Nazis, Eisen and three fellow prisoners staged a daring escape.

Hilda Eisen's World War II story is just as chilling. She fought with the Jewish Resistance, repeatedly evading capture. When caught, she survived an unspeakable crime, only to escape once again to fight on. The Eisens grew up together in Izbica-Kujawska, Poland, reunited again at the war's end, and married in 1945 after having lost their entire families in the Holocaust.

The Eisens' impact on Norco has been multifaceted. For decades, they were one of the largest employers in Riverside County, and their generous charity efforts are truly legendary. Perhaps most long-lasting is their completely forgotten contribution to Norco's successful battle for incorporation in 1964 against moneyed developers, a battle almost completely funded by the Eisens. Once Norco became a city, financial struggles followed. Very quietly, Harry and Hilda Eisen donated $10,000 to keep Norco afloat. In a very real way, there would be no Norco had it not been for the support of Harry and Hilda Eisen. (Michael Eisen.)

Lois Richards

In 1975, Lois Richards was officially appointed Norco's first city historian; a combination of luck and caring were set into motion. The old-timers who settled the valley between 1909 and the 1930s were dying off, leaving behind photographs, letters, and other items detailing Norco's history. Richards scooped them up and protected and saved them, creating the foundation for Norco's extensive archives. (Richards family.)

Norva Williams

A longtime Norconian, Norva Williams is well known for her volunteerism and for protecting the community's rural lifestyle. She has served many Norco candidates over the years as campaign manager, knocking on doors and twisting not a few arms for donations. She is also a huge supporter of the Horsetown USA Hall of Fame and the Lake Norconian Club Foundation and their efforts to preserve the magnificent Norconian Resort Supreme.

Help us to preserve our hidden treasure in Norc

Hugh Underhill

Larger than life, Underhill was elected the Temescal Township constable in 1946, making him the law in unincorporated Norco. Underhill was famous for sentencing juvenile speeders to hard labor, "relentlessly pursuing chicken thieves," and a gunfight in which he saved a young girl from "a fate worse than death." A noted equestrian, Underhill's Norco Ranch was the site of many "a knee slappin' party." (Debbie Talbert.)

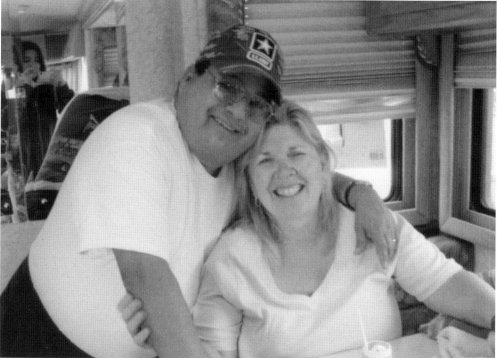

Bobby Mendoza

After returning from Vietnam, Bobby married his high school sweetheart, Becky, and embarked on a career as a respected educator working with at-risk kids. Upon retirement, with Becky at his side, he pulled some veteran buddies together and began a second career: providing music for weddings, dances, and, at no charge, to multiple charities and veteran's events. Mendoza is a truly kind and generous American. (Becky Mendoza.)

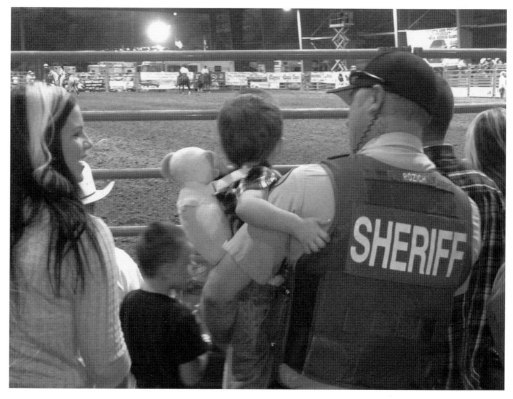

Cpl. Dan Rozich

Norco has been protected by the Riverside County sheriff since 1898 and was the first city to sign a contract for law enforcement services in 1964. Norco is one of the few cities to have its own sheriff's substation. Deputies like Dan Rozich (seen here watching the rodeo with a "friend") are prized by residents and considered part of the community—except when writing a speeding ticket, of course.

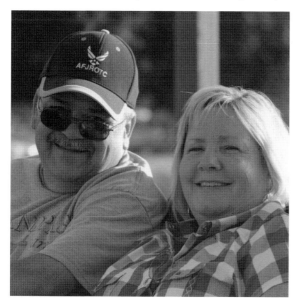

John and Joanne Aikins

The Aikinses exemplify Norco volunteerism and selfless service at its best. Soft-spoken John, when supporting a cause, takes on just about anything that needs to be done. And he supports a lot of causes. His wife, Joanne, follows suit with the same good humor and dedication. No job is too small or too large for these truly kind and invaluable members of the Norco community. (Joanne Aikins.)

Jo and Joe McEuen

The McEuens are active members of the volunteer Citizens on Patrol and support numerous events and charities. Both have long been active in local politics, and Joe is quite an entertainer, with a beautiful singing voice. He currently entertains with an ukulele performance group. Jo and Joe are truly remarkable and valued residents of the community. Here, they receive an award from Norco's chief of police, Eric Briddick. (Eric Briddick.)

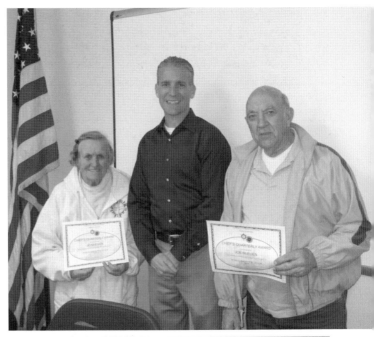

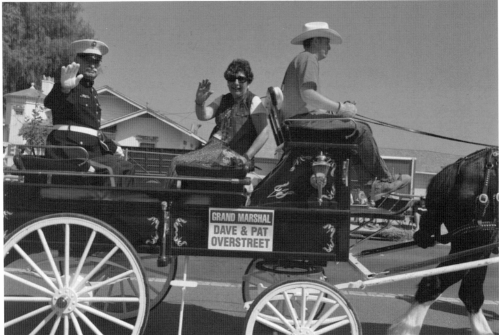

Dave and Pat Overstreet

The Overstreets are prolific volunteers whose activities range from working with political groups to supporting multiple charities and nonprofit organizations. No job is too small for Pat, a retired nurse, or, Dave, a decorated Vietnam veteran. Both are known for their kindness and hospitality, opening their home regularly to assist a wide variety of causes. And both are fierce advocates of Norco's rural lifestyle. (Brigitte Jouxtel.)

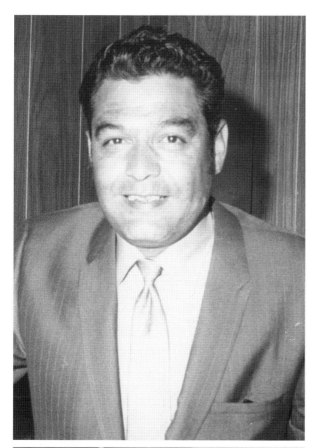

Simon Melendez
During the Korean War, Melendez rose to the rank of first lieutenant in the Air Force and flew 21 combat missions. A graduate of the University of Southern California, Melendez served as Norco's city manager from 1969 through 1976 and was likely the first Hispanic city manager in the state of California. He is credited with moving Norco from a struggling rural community to a full-service city. (Corona.)

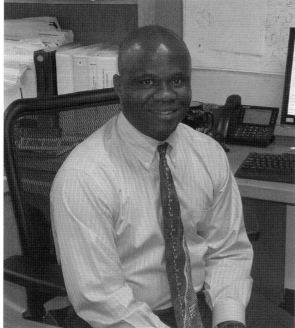

Andy Okoro
Born in Nigeria, current city manager Andy Okoro immigrated to the United States in 1980, received a degree in business and accounting from Wichita State, and was hired as Norco's fiscal and support services manager in 2003. He rose to finance director, deputy city manager, and, following the retirement of popular Beth Groves, was appointed city manager in 2013. He is friendly, extremely ethical, and considered one of the best public finance minds in California.

Allen and Betty Bash

In 1961, Allen Bash convinced his very reluctant wife, Betty, to relocate from her tidy Anaheim tract home to a rundown, five-acre former pig farm in Norco.

Betty had a dream of opening a "children's development center," and Town and Country Day School was born in 1962. Over the next few years, Allen converted the dilapidated house and barn into classrooms and built imaginative playgrounds, while Betty developed a pioneering approach to preschool education and pushed to bring professionalism into a business that was once considered nothing more than "a baby-sitting service." Allen, who was incapable of saying "No" to any kid with a fundraising candy bar to sell, passed away in 2005. More than 50 years after its establishment and having served thousands of kids, Town and Country, the oldest same-owner business in Norco, and Betty Bash are still going strong. It is recognized as one of the best preschool, extended-day, and kindergarten programs in Riverside County.

Alton Vance

Vance arrived in the mid-1970s to take the reins of the Norco Christian Church. He literally invited his congregation to saddle up in 1989, when he introduced the outdoor "Cowboy Church." At this Sunday service, equestrians can tie their animals to a hitching post and hear the Gospel. Pastor Alton is also known as an accomplished photographer and is said to play a pretty mean banjo. (Alton Vance.)

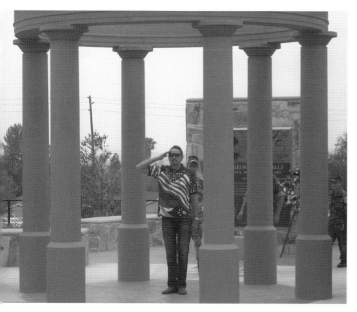

Vernie Fletcher

Over 40 years ago, "Pastor Vernie" had no idea when he accepted leadership of the Grace Fellowship Church that it would become his life's work. With good humor through tough times, Fletcher has overseen the church's remarkable growth, and his service to the community is widespread and truly noteworthy. A decorated Vietnam combat veteran, Fletcher was key to building the George A. Ingalls Veterans Memorial Plaza. (Brigitte Jouxtel.)

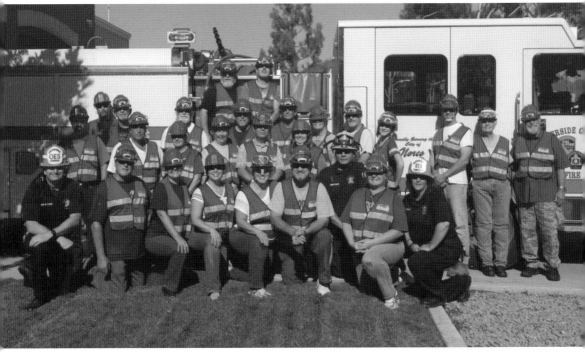

Community Emergency Response Team (CERT)

Pictured is the first group of Norco volunteers to complete CERT training: a comprehensive program designed to train regular folks to be prepared, ready, and able to assist others in a catastrophic incident such as an earthquake, major fire, or other situation. These volunteers come from every walk of life, ranging from housewife to plumber to cop and everything in between. (Cal Fire.)

Paul Miller

"Coach" Miller represents a completely unheralded group of volunteers who, generation after generation, sacrifice money and time to coach the community's children. Miller, seen here at center with Bobby Miller (left) and Kevin Bash (right), was quick with a smile. He was a patient taskmaster whose players developed skills while having fun. Miller made kids who played baseball for him feel like Sandy Koufax, Willie Mays, and Mickey Mantle all rolled into one. (Bonnie Miller.)

Ben Gonzalez
Gonzalez grew up in Norco, excelled in track at Corona High, and served in Vietnam. He worked for decades at Norco High as teacher, coach, and athletic director, and his positive impact on students' lives is long-lasting. He once "encouraged" a young athlete, Alan Bash, to run the Norco Hills lugging a shot put until he learned discipline. It was a cherished memory and turning point for that future champion. (NHS.)

Diana Stiller
A local girl, described by colleagues as "a teacher's teacher," Stiller began at Norco High School teaching social studies in 1999. Outside the classroom, Stiller actively pursues the preservation of the community's history as a member of the Norco Historic Commission. She was selected to conduct worldwide study tours through the World Affairs Council and the US and California Department of Education Cooperative Education Exchange Program. (Diana Stiller.)

Nathan Miller

Following the division of the Riverside Community College District into separate voting areas, Miller, with his trademark bow tie, was elected as the first trustee to specifically represent Norco College. A tireless, fun, and inspiring campaigner for improving education quality, Miller believes, "You can always succeed justly with integrity; you just might have to work longer and harder to get there the right way." (Nathan Miller.)

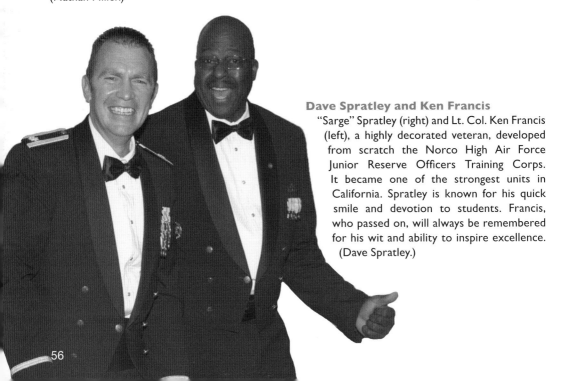

Dave Spratley and Ken Francis

"Sarge" Spratley (right) and Lt. Col. Ken Francis (left), a highly decorated veteran, developed from scratch the Norco High Air Force Junior Reserve Officers Training Corps. It became one of the strongest units in California. Spratley is known for his quick smile and devotion to students. Francis, who passed on, will always be remembered for his wit and ability to inspire excellence. (Dave Spratley.)

Dr. William Herron

Veterinarian "Doc" Herron was truly old Norco, gregarious and well known for his community involvement as a member of the school board, community services district, and Norco City Council. However, today he is most famous for his legendary acceptance of an offer by a constituent "to step outside" and the subsequent fistfight that spilled out onto the steps of city hall. He was known thereafter as "the battling mayor." (Corona.)

Donny Gouthro

When Norco's veterans' memorial was proposed, a small group of vocal residents opposed spending the money. On the night that the city council was to make the decision, angry veterans packed the chambers, and Donny Gouthro was the first to speak. He loudly asked, "Who is opposing this memorial?" Every veteran turned and glared at those in opposition. The opponents did not say another word, and the council approved the project unanimously.

Norco Birthday Cake

To celebrate Norco's 50th anniversary as a city, Councilwoman Kathy Azevedo wanted a cake—a big cake! So the Future Farmers of America chapter at Norco High School built a impressive 10-foot high, five-decker wooden pastry. Councilman Greg Newton (left) and Mayor Berwin Hanna (right), as "keepers of the cake," rolled, pulled, and displayed it at parades and other events for an entire year! (Brigitte Jouxtel.)

Bob Prior

Professor Prior was one of the founding teachers at Norco College in 1991 and a longtime member of the Norco Kiwanis. A math teacher by trade, Prior is a bit of a Renaissance man, with deep skills that include writing textbooks. He also has a truly wonderful singing voice. Kind, soft-spoken, with a smile that lights up a room, Bob Prior is completely dedicated to his family, students, and community.

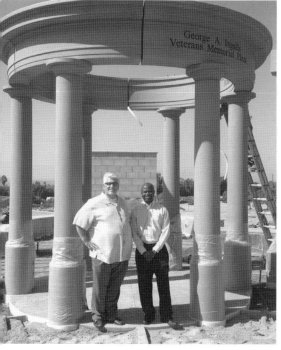

Legendary Team

The parks and recreation staffers in the above photograph, Robin Shepard (center) and Michelle England (right), pictured with Brian Petree, were key to the completion of the George A. Ingalls Veterans Memorial Plaza. England created publicity and verified every name on the wall of honor. Shepard had the task of ensuring that the engraved bricks were perfect, personally placing each one by hand.

Parks and recreation director Brian Petree, shown at left in the photograph at left, managed the project. He inspired the community when he stood firm against some citizens who questioned the cost, stating, "Norco is going to build this memorial right for those who gave everything to defend our country, or I don't build it." Construction began with only a few thousand dollars in place. But Andy Okoro, Norco's city manager (at right in the picture at left) miraculously found $500,000 in state funding, kicking off $1 million in donations.

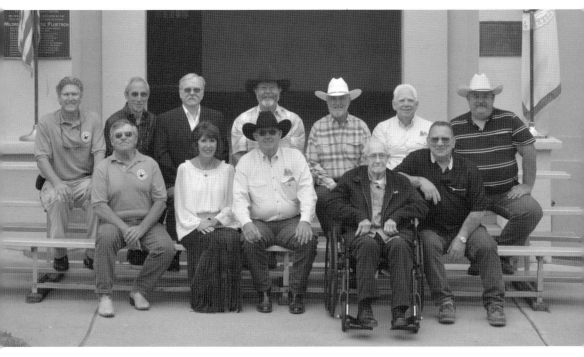

Norco City Council

On December 28, 1964, Norco officially became a city. The first council consisted of Gil Cox (mayor), Dr. John Koning, Tom "Shorty" Harris, Bert Range, and Louis Hoefs. Thus began a Wild West show of fistfights, recalls, packed council meetings of angry residents, and a 50-year history of council after council miraculously protecting Norco's rural lifestyle.

In 2014, former and current city council members sat for this commemorative photograph. Shown are, from left to right, the following: (first row) Greg Newton, Kathy Azevedo, Berwin Hanna, Red Taylor, and Herb Higgins; (second row) Kevin Bash, John Casper, Larry Cusimano, Terry Wright, Harvey Sullivan, Dick McGregor, and Robb Koziel.

Norco City Council members from 1964 to 2015 have included the following: Kathy Azevedo (2003–2015), Kevin Bash (2009–2017), Harry Brinton (1973–1980), Richard "Doc" Brown (1973–1977), Barbara Carmichael (1990–2003), Larry Cusimano (1990–1995), John Casper (1984–1990), Hal Clark (1997–2008), John Cobbe (1986–1990), Gil Cox (1964–1968), Louis deBottari (1972–1973), Naomi Feagan (1978–1986), Lori Gregg (1977–1982), Frank Hall (1997–2009), Berwin Hanna (2007–2014), Tom "Shorty" Harris (1964–1970), William Herron (1968–1972), Louis Hoefs (1964–1970), Herb Higgins (1999–2007; 2011–2015), Bill Jarrett (1970–1973), Phil Jones (1977–1984), Bud King (1972–1973), John Koning (1964–1968), Rob Koziel (1995–1999), Richard McGregor (1982–1995; 2008–2009), Art McCollum (1973–1976), Malcolm Miller (2007–2010), Steve Nathan (1978–1990), Greg Newton (2010; 2013–2017), Bert Range (1964–1966), Jerry Riley (1976–1977), Chris Sorensen (1995–1999), Harvey Sullivan (1999–2007; 2009–2013), Red Taylor (1967–1978), William "Bill" Vaughan (1990–1997), Ivan Warrick (1968–1972), Nellie Weaver (1970–1978), Ron Wildfong (1980–1990), and Terry Wright (1990–1997). (Brigitte Jouxtel.)

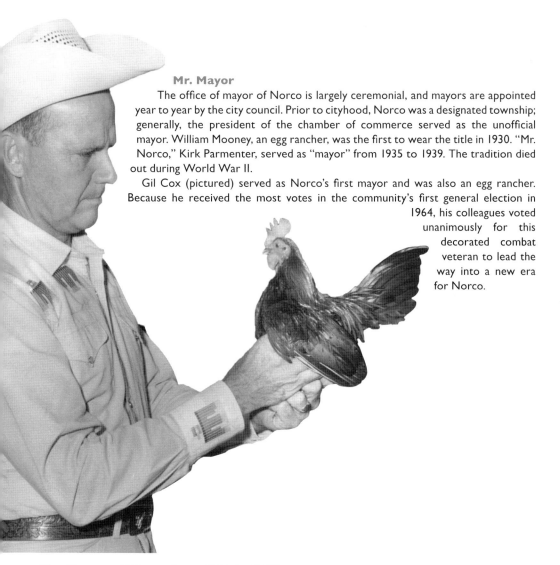

Mr. Mayor

The office of mayor of Norco is largely ceremonial, and mayors are appointed year to year by the city council. Prior to cityhood, Norco was a designated township; generally, the president of the chamber of commerce served as the unofficial mayor. William Mooney, an egg rancher, was the first to wear the title in 1930. "Mr. Norco," Kirk Parmenter, served as "mayor" from 1935 to 1939. The tradition died out during World War II.

Gil Cox (pictured) served as Norco's first mayor and was also an egg rancher. Because he received the most votes in the community's first general election in 1964, his colleagues voted unanimously for this decorated combat veteran to lead the way into a new era for Norco.

The Mayors of Norco from 1964 to 2015

Norco's mayors have been: Gil Cox (1964), Gil Cox (1965–1966), Louis Hoefs (1966–1967), John Koning (1967–1968), Red Taylor (1968–1969), Ivan Warrick (1969–1970), Ivan Warrick (1970–1971), William Herron (1971–1972), Bill Jarrett (1972–1973), Nellie Weaver (1973–1974), Harry Brinton (1974–1975), Richard Brown (1975–1976), Nellie Weaver (1976–1977), Jerry Riley (1977), Harry Brinton (1977–1978), Lori Gregg (1978–1979), Phil Jones (1979–1980), Naomi Feagan (1980–1981), Steve Nathan (1981–1982), Ron Wildfong (1982–1983), Steve Nathan (1983–1984), Dick McGregor (1984–1985), Dick McGregor (1985–1986), Ron Wildfong (1986–1987), John Casper (1987–1988), Dick McGregor (1988–1989), John Cobbe (1989–1990), Dick McGregor (1990–1991), Barbara Carmichael (1991–1992), Larry Cusimano (1992–1993), William Vaughan (1994), Terry Wright (1995), William Vaughan (1996), Rob Koziel (1997), Chris Sorensen (1998), Barbara Carmichael (1999), Frank Hall (2000), Hal Clark (2001), Herb Higgins (2002), Harvey Sullivan (2003), Frank Hall (2004), Herb Higgins (2005), Kathy Azevedo (2006), Harvey Sullivan (2007), Frank Hall (2008), Kathy Azevedo (2009), Malcolm Miller (2010), Berwin Hanna (2010), Berwin Hanna (2011), Kevin Bash (2012), Kathy Azevedo (2013), Berwin Hanna (2014), Herb Higgins (2015), and Kevin Bash (2016).

Sweet Lou

For decades, Lou Rivera has been batting coach and philosopher to pupils, ranging from a 10-year-old unable to hit a curve or pay for lessons to a veteran still fighting to "come home." Recently, a neighbor complained about the noise coming from Rivera's home batting cage and wanted him shut down. Generations of kids, many now parents, stormed city hall, and Sweet Lou prevailed.

Nicole Hansen

Hansen followed in her parents' footsteps and took over the reins of the popular Villa Amalfi Ristorante, relocating it to the beautiful Hidden Valley Golf Course in Norco. In great demand as a caterer serving business grand openings and corporate functions, Hansen, an extremely astute businesswoman, expanded her operation to include the Hidden Valley Event Center, a beautiful complex capable of handling large events, particularly weddings and receptions.

Hedwig Rauth

Rauth was born in Zurich, Switzerland, spoke eight languages, grew up laboring on the family's pioneering farm in the heart of what is now Hollywood, was sent to study at the Conservancy of Music in Leipzig, Germany, as a prodigy, and traveled Europe as a premier concert violinist. She married dashing attorney Mr. Rauth, and her entire family, all of who were American citizens and noted musicians, returned to Switzerland.

By 1941, Hedwig and her husband had moved to Germany, where she was much in demand as a performer. One evening, she received a call that the Nazis had arrested her husband for espionage, and she rushed to see him. Upon arrival, she was held and questioned about her American citizenship and then sent to a concentration camp for two years, where she received a telltale tattooed number on her wrist. She credited her ability to play the violin for the camp staff every evening at supper for saving her life. Miraculously, when her health began to fail and it became difficult to play, a lowly guard, understanding that her value had diminished, supplied Rauth with a pass and "accidently" released her in 1943. The Gestapo had the guard shot and was relentlessly bent on correcting the "accident." Rauth incredibly discovered that her husband, who actually was an Allied spy and had been branded an "enemy of the Reich," was also escaping to the country on the same train.

The couple moved from place to place, avoiding the Nazis, losing all of their possessions (including a Stradivarius violin) and many friends who harbored the fugitives during Allied bombings. Hedwig was finally smuggled to the United States in the midst of World War II, thanks to the intervention of famed violinist Jascha Heifetz and comedian Jack Benny. Her husband, as a German citizen, was denied access to the United States. He was forced to stay behind, and, at the end of the war, he was trapped behind the Iron Curtain. Considered a national hero, Mr. Rauth could not leave communist Germany and was never reunited with his wife.

Penniless, Rauth was cared for and relocated to Norco in the late 1940s by the Seventh-Day Adventists and spent her last years living quietly and tending her garden. Sadly, she ceased playing music, because her prison-camp ordeal had stripped her of "strength and vitality;" her "music was gone." (Corona.)

Sparky Panzer
A master electrician, Sparky Panzer is a larger-than-life leatherneck always ready to assist a Boy Scout putting together an Eagle Scout project, a senior citizen with an electrical problem, and, most of all, any veteran in need. Panzer and his motorcycle have escorted dozens of warriors home, and he refused payment for his massive efforts toward the completion of the George A. Ingalls Memorial Plaza. (Brigitte Jouxtel.)

Dawn Panzer
As the representative for the Lions Club of Norco, Dawn, who owns one of the great smiles, has presented a very special gift, paid for by members, to several deserving young men: their official Eagle Scout Commemoration Ring. The Lions established and have sponsored Norco's Boy Scout Troop 33 for over 50 years. Along with this duty, the Lions support numerous charities and community events with truly extraordinary volunteerism.

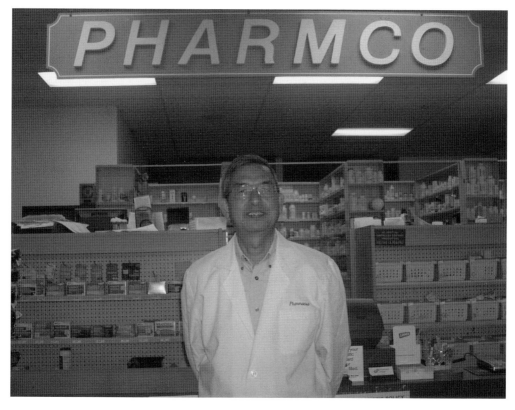

Larry Kwok

A soft-spoken, exceedingly gracious neighborhood pharmacist, Larry Kwok is quite simply a Norco institution. Owner of long-established Pharmco Drug, Inc., on Hamner Avenue, Kwok is known for his friendly, caring customer service and dedication "to keeping his customers healthy." He is proud to have served many families over several generations, and his quiet support of seniors in the community is a well-known secret.

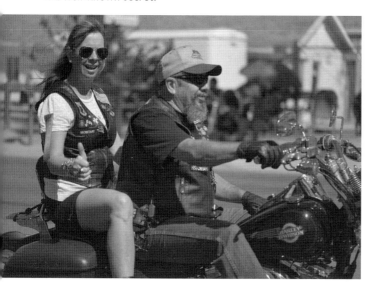

Roy Kennedy

As members of the American Legion Riders, Roy and his wife, Patty, are two of many Norconians who raise thousands of dollars for local children's hospitals, severely wounded veterans, and scholarships for students. They escort returning servicemen and servicewomen to their families and provide motorcades for those veterans making the "ride home to their final resting place." Roy Kennedy is also famous for his vintage fire truck. (Brigitte Jouxtel.)

Esther Ann Walker

The first widely known Norco beauty-contest winner was Esther Ann Walker (left, with fellow American Legion Miss American beauty contestant Ann Lee Roberts). She was a ringer from nearby Ontario brought in to win the title Miss Norconian 1938. Rex Clark recruited the beauty midway through the contest, ticking off the local contestants and their parents. Sponsored by the local American Legion, Esther spent the next year representing the Norconian resort at fairs, conventions, and fashion shows. She placed third in the Miss California Contest. Here, Walker stands on the world's biggest plow in 1938.

Over time, a few short-lived contests produced Miss Norco Chamber of Commerce, the Queen of the Poultry and Rabbit Show 1935, the Navy Hospital's Corpsman's Choice, and the Naval Ordnance Laboratory's Missile Queen. Today, Miss Norco is known as Miss Norco Horsetown USA.

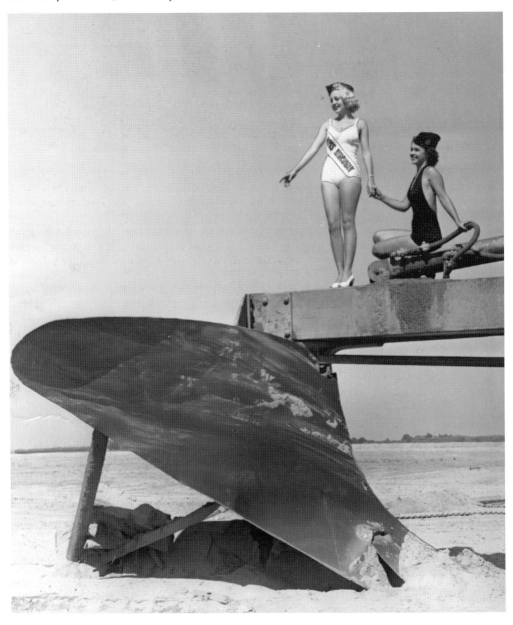

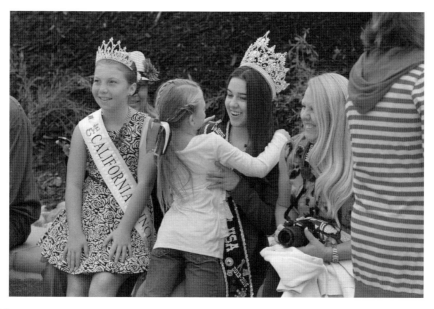

Miss Norco

Vivacious Destinee Ann Palladino (center) is the current, hardworking Miss Norco Horsetown USA. In 1949, the Norco Fair was launched, and the inaugural Miss Norco was crowned. Winning was based on audience applause registered by a "Clap-O-Meter." Controversy swirled around the contest when contestants charged that the winner won with bribes of candy.

Over time, the Miss Norco contest evolved from merely walking around the community pool, reciting life goals, and producing a recipe for homemade jam to competitive affairs requiring serious entertainment capabilities and professional coaches and judges. Years of turmoil ultimately led to the crowned queen being named Miss Norco Horsetown USA.

The following women have been named Miss Norco: Betty Turner (1949–1950), Marie Woodworth (1950–1951), Imogene Shockley (1951–1952), Beverly Jean Annis (1952–1953), Marilyn Williams (1953–1954), Marion Hazen (1954–1955), Marie Rycraft (1955–1956), Gloria Dion (1956–1957), Carol Schneider (1957–1958), Dottie Brinton (1958–1959), Bonnie Rose (1959–1960), Janice Williams (1960–1961), Raynette Berry (1961–1962), Darlene Tiemeyer (1962–1963), Carol Adams (1963–1964), Martha Jane Carther (1964–1965), Linda Mallicoat (1965–1966), Denice Robinson (1966–1967), Patricia Mallicoat (1967–1968), Vickie Cairns (1968–1969), Gail Marlow (1969–1970), Linda Benjamin (1970–1971), Rochelle Wallace (1971–1972), Linda White (1972–1973; stepped down), Wendy Woodforde (1972–1973), Karen Mallicoat (1973–1974), Tawny Aungst (1974–1975), Mical Martin (1975–1976), Marty Landmesser (1976–1977), Patti Lusk (1977–1978), Dana Bendall (1978–1979), Sandi Halverson (1979–1980), Shamra Thompson (1980–1981), Rhonda Raynor (1981–1982), Shawna Gonzales (1982–1983), Cheryl Fenton (1983–1984), Trina Padgett (1984–1985), Lynn Freberg (1985–1986), Kam Hansen (1986–1987), Diana Hart (1987–1988), Stephanie Longo (1988–1989), Stephanie Volp (1989–1990), Paula Bogema (1990–1991), Lori Lorenz (1991–1992), Kelli Shaffer (1992–1993), Sasheen Pack (1993–1994), Danielle Galliffa (1994–1995), Jamie Casper (1995–1996), Bethany Garcia (1996–1997), Tiffany Macias (1997–1998), Tenetia Hollingsworth (1998–1999), Kasey Hoggarth (1999–2000), Heather Collins (2000–2001), Ashley Travis (2001–2002), Denene Davidovich (2002–2003), Chelsea Keene (2003–2004), Nicole Brunswick (2004–2005), Vanessa Vance (2005–2006), Lynsey Stanfield (2006–2007), Kara Ann Knudsen (2007–2008), Nicole Schulz (2008–2009), Brooke Conlin (2009–2010), Kylie Swanson (2010–2011), Audri Ann Counts (2011–2012; stepped down), and Jessica Riner (2011–2012).

The following women have been named Miss Norco Horsetown USA: Kristyann Miller (2009–2010), Kylie Swanson (2010–2011), Destinee Ann Palladino (2013–2014; 2015), and Tommi Bowers (2015–2016). (Brigitte Jouxtel.)

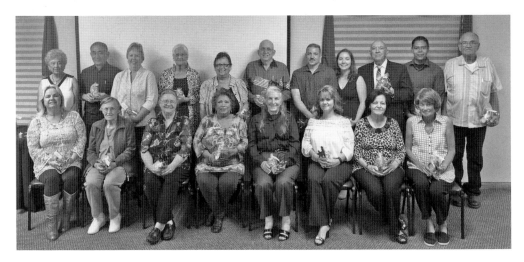

Legendary Volunteers

One of Norco's most valued volunteer groups, Citizens on Patrol, formed in 1995 to assist the county sheriff's department. Patrol members donate thousands of hours patrolling Norco streets, responding to calls for assistance, checking on seniors, watching homes of vacationing citizens, providing traffic control, and saving the City of Norco hundreds of hours in deputy costs. From left to right are (first row) Debra Martinez, Jo McEuen, Joann Watson, Rose Rios, Deborah Worley, Veronica Hubbard, Samia Yousef, and Judy Rossel; (second row) Tricia Burns, Tomas Caragan, Jerri Chamberlain, Anna Harper, Deborah Garner, Jim Hosley, Al Juan, Joyce Lee, Joe McEuen, Guillermo Perez, and James Wheeler.

Wanda Crowson

A longtime real estate broker and owner of the Century Property Management, Crowson is also heavily involved in several charities, particularly the Parade of Lights and Winter Festival. She served many years on the City of Norco Economic Development Advisory Committee. Posing here with Wanda is her husband, Kent, a man of few words but also an extremely dedicated volunteer. (Crowson family.)

CHAPTER FOUR

Big Leagues, Top of the Heap, Show Biz, and Elvis

Norco has had quite a few people who have gone on to stardom in collegiate and professional athletics and in show business. In addition, a number of folks settled in the community during or after retiring from remarkable careers. Si Otis, once an international circus headliner who performed with his famed mule, Abner, finished out his time caring for Gene Holter's exotic animals and delighting kids with amazing comedy routines. Jim Fregosi of the California Angels lived in Norco for a time, as did Troy Glaus. Grace Artinian Ball retired in Norco after a career as a well-known, glass-shattering coloratura who also worked regularly as a radio actress in the 1940s.

For many years, Norco was the winter home for several circuses and acts, including the Johnny Cline Circus, Bentley's French Poodles, Bill "Buckles" Woodcock and his elephants, Richard Berg's seal act, and the "Oriental Contortionists Chi and Suma."

Beginning in the 1920s, Norco and the surrounding area were heavily used for Hollywood productions: Harold Lloyd, Will Rogers, Rudolf Valentino, Errol Flynn, Francis Farmer, Mae West, Mack Sennett, Ida Lupino, Spencer Tracy, Clark Gable, Barbara Eden, and Guy Madison are just a few of the stars who filmed in and around Norco.

The 1928 Olympic divers and swimmers christened the Norconian Club pools that for several years held huge events, with the best athletes of the day competing. Duke Kahanamoku, "The Big Kahuna," was a famed Olympian who frequently demonstrated the sport of surfing by riding a board pulled by a speedboat on Lake Norconian. Though hugely popular with the crowds, "The Duke" was unable to rent a room in the resort because of the color of his skin.

During the Norconian resort era (1928–1941), the biggest Hollywood stars stayed and played in Norco and later returned to entertain and visit patients at the US Naval Hospital that took over the famed hotel in 1942 to care for wounded sailors and Marines.

The Chicago Cubs, who held spring training on Catalina Island, supplied ballplayers for several Joe E. Brown baseball comedies shot in the area, as did the Pacific Coast League Los Angeles Angels. Both teams returned to play exhibition games for naval hospital patients. Hall of famer Bill Veeck lived in Norco for many months on the fourth floor of the hospital, where he lost his battle to save his leg from war injuries.

Norco has produced extraordinary folks who have gone on to success in all fields. Dr. Gary L. Jones is a successful physician; Carl Ledbetter was chosen to protect the procession of the Unknown Soldier; and Tom Whitaker was the 1965 National Junior Small Bore Rifle Position Champion.

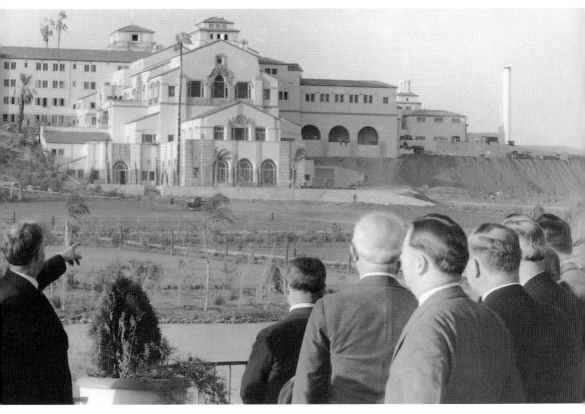

Rex Clark and Norconian Resort

Stories of movie stars, gangsters, wild parties, and ghosts surround the magnificent Norconian Resort Supreme, built with millions of dollars from the Scripps family fortune. Rex Clark (left), seen here showing visitors his soon-to-be-finished masterpiece, essentially abandoned Norco's downtown project to construct a 700-acre playground, complete with a lake, 18-hole golf course, airfield, chauffeurs' quarters, garage, state-of-the-art laundry, opulent dining facilities, gymnasium, outdoor competitive diving and swimming pools, and plush hotel rooms and suites. Movie stars, famed athletes, and the wealthy from all walks of life flocked to the resort to luxuriate in the hot-spring baths. Guests were entertained with diving and swimming competitions featuring the finest Olympic athletes, several films were shot on the grounds, high-speed motorboat races were regular attractions, and well-known big bands drew hundreds of dancing guests.

Builder Rex Clark was congratulated from coast to coast on the day of his grand opening on February 2, 1929. Short months later, Black Tuesday heralded the coming of the Great Depression, and Clark's "triumph" quickly became known as "Rex's Folly." Over the next 10 years, the resort struggled financially, opening and closing. It likely never made a nickel, and it shut down for good in 1941.

Pete the Dog

On April 6, 1946, one of several dogs that played "Petey" in the *Our Gang* comedies was shot and killed in Norco. Riddled with buckshot, Pete died as he tried to drag himself home. E.R. Lloyd, a veteran studio employee who was given the dog by producer Hal Roach, claimed, "Petey was a member of the family." The crime was never solved.

Brigitte Jouxtel Bash

Born in Vietnam to a famed French soldier, Brigitte relocated to the United States and transformed herself into one of the top Hollywood photographers. Moving to Norco in 1995, she began to photograph the community's daily life, creating a breathtaking library of images. Perhaps her greatest contribution is the hundreds of color photographs she took of the former Norconian Resort Supreme—images that might just save this national treasure.

Don Durant

Durant was the first Norconian to gain stardom in Hollywood. Arriving in Norco as a five-year-old, Durant broke into show business with his own radio show while attending Corona High School. After a stint in the Army and Navy, he toured in plays, signed a bit contract with CBS, and finally hit it big singing with the big bands of Tommy Dorsey and Ray Anthony. His movie break came with the lead in *She-Gods of Shark Reef*, which led to a string of good parts in some of the best television programs of the 1950s and 1960s, including a famous *Twilight Zone* episode. In 1959, Durant won the tile role in the series *Johnny Ringo*, portraying "the fastest gun in all the west," but the program was cancelled after one season. Disillusioned with Hollywood, Durant successfully pursued a career in real estate.

Kathy Westmoreland

The daughter of professional entertainers, Kathy began her career with high school classmate Steve Martin doing a musical comedy act at the Birdcage Theatre at Knott's Berry Farm. She moved on to musical comedy, performed with the Metropolitan Opera, joined the Sandpipers ("Guantanamera"), appeared on numerous television programs, and worked with Elvis Presley, who introduced her as "the little girl with the beautiful high voice." (Brent Westmoreland.)

Burt Ward

A longtime Norconian, Burt Ward (center) has two claims to fame. At 19, he was cast as Robin in the 1960s television program *Batman*, and to this day he is identified as the "Boy Wonder." And in more recent years, he and his wife, Tracy, have operated the Gentle Giants Rescue and Adoptions, Inc., and dedicated their lives to protecting and saving large-breed dogs. (Charles FitzSimmons.)

Fred and Dorothy Blair
Known professionally as "Blair and Dean," this dancing duo performed as top-notch headliners in some of the best nightclubs in the nation, including the Coconut Grove in Los Angeles and New York's Copacabana. With the demise of nightclubs, the Blairs retired to Norco in 1963, becoming active in local politics, community theater, and the restaurant business. For several years, they staged the Norco Fair Variety Show. (Corona.)

Gene Holter
In 1949, the *Corona Daily Independent* ran the headline "Owner of Strange Animals Buys Ranch in Norco," and the floodgates were opened to llamas, more ostriches than anywhere else "in the US," elephants, hippopotami, zebras, zonkeys, camels, kangaroos, and the "Mystery Animal" (a yak). Former stuntman Holter eventually unveiled his famed Wild Animal Show, featuring ostrich races, trained horses, dog acts, lions, tigers, and chimps!

Big Babe

This Norco-based pachyderm was a bona fide star, appearing in over 200 movies, including *The Big Circus, Around the World in 80 Days,* and *Elephant Walk.* This five-ton performer appeared across the country in Gene Holter's Wild Animal Show and thrilled audiences with stunts such as "The Human Lollipop," seen in this photograph.

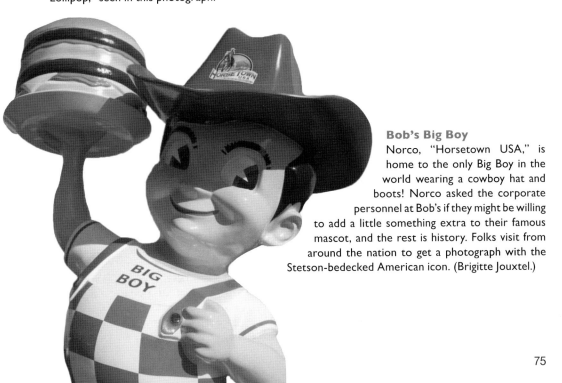

Bob's Big Boy

Norco, "Horsetown USA," is home to the only Big Boy in the world wearing a cowboy hat and boots! Norco asked the corporate personnel at Bob's if they might be willing to add a little something extra to their famous mascot, and the rest is history. Folks visit from around the nation to get a photograph with the Stetson-bedecked American icon. (Brigitte Jouxtel.)

Rudy Jacobi

For almost two decades, ringmaster Jacobi's magical Rudy Brothers Circus wintered in Norco. Some of the biggest acts traveled with Rudy Brothers, and many times, one could catch lion tamers, high-wire acts, and clowns rehearsing for the new season. Jacobi (third from right) was a welcoming man, and it was not unusual to find numerous kids watching the performers practice. But one never touched the animals!

Fred Crook

In Norco since 1985, Fred Crook and his family have operated Quick Crete Products Corp., a nationally known industry leader producing a line of concrete products ranging from park benches to fountains to elaborate memorials "to anything and everything you can imagine." The Crook family generously donated the spectacular rotunda for the George Ingalls Veterans Memorial Plaza. Fred Crook was a tireless supporter of University of Southern California football. (Crook family.)

Jack Beckman
"Fast Jack" Beckman is a family man, cancer survivor, Air Force veteran, advocate for injured veterans as a member of the Infinite Hero team, and two-time racing world champion (Funny Car 2012; Super Comp 2003). Beckman, who in 2015 traveled 322.65 miles per hour, is a familiar sight in Norco. Extremely humble and friendly, he is a force to be reckoned with when it comes to supporting veterans and children. (Jack Beckman.)

John Casper
Respected, well-known newsman John Casper and his video camera began recording the news in 1994, beginning with a dead body emanating toxic fumes, to everything from fires, homicides, exploding lemonade stands, and a naked burglar. A believer in community service, Casper was an outstanding Norco City councilman and has been a staunch advocate for protecting the community's rural lifestyle. (John Casper.)

Jerry Soifer

Though not a Norconian by address, as a reporter and photographer for the *Riverside Press Enterprise*, Soifer has photographed and written about Norco, and Norco football in particular, for over 30 years. He can recount most of the greatest plays in the high school's gridiron history. While his subject matter is broad, Soifer is renowned as a sports photographer who has shot NFL Raiders football games for three decades.

Michael Hickey

Michael and his late wife, Velma, operated the *Norco News* for nearly two decades. Serving as the paper's photographer, Michael (and his camera) was a familiar sight literally everywhere, from sporting events to the Annual Pet Parade. His library of photographs is simply staggering. For his extensive charitable contributions and volunteer efforts, Michael was named the Norco Chamber of Commerce Man of the Year in 2007.

CHAPTER FIVE

Tall in the Saddle

Following World War II, a housing boom erupted in Riverside County to cater to the thousands of veterans stationed at or passing through the US Naval Hospital, Camp Haan, Camp Anza, and March Air Field and who then decided to stay. Next came the families whose breadwinners captured jobs with the burgeoning defense industry.

Almost overnight, farms and ranches disappeared, and thousands of cheaply built cracker-box houses on small lots appeared, replicating what was happening throughout Southern California. A countywide zoning plan was inaugurated in the late 1940s to curtail the chaos created by "here today and gone tomorrow developers looking for a quick buck."

Norco, not yet a city, but with a growing population of equestrians who had been driven from other communities when their horses were zoned out, fought back in a battle described as "houses vs. horses." The goal was to protect the large lots, create trails, and preserve open space. Norco became a city in 1964 specifically to preserve "city living in a rural atmosphere," and city council after city council has fought outside developers and "those damn residents from Orange County" to "keep Norco, Norco!"

By the mid-2000s, Norco was trademarked and branded as "Horsetown USA," and it remains home to some of the finest equestrians in the nation, including rodeo champions, famed jockeys, trainers, hunter jumpers, polo players, and some darn fine trail riders. There is a trail on most streets, arenas in just about every park, houses on a half-acre or more by ordinance, and access to open space via the ridgeline to the east and the Santa Ana River to the west and north.

Equestrian groups—some gone, some still active—have included generations of remarkable members, and it is impossible to pick one person out for recognition. The Norco Horseman's Association, the Saddle Sore Riders, Equestrian Trails, Inc., the old Norco Valley Riders, and even Norco's first known equestrian group, the Hill Billy Riding Club, all had members and leaders worthy of being called legendary locals.

Sadly, many are forgotten, such as Ray Maddox. In 1968, he was the chair of Norco's first equestrian trails advisory committee, and he oversaw the installation of the first trail markers (Pedley Avenue) and trail fencing (plastic, in front of city hall). The committee was comprised of members of the various riding groups. Its early recommendations included no trails on dangerous streets and a horse tax to fund maintenance.

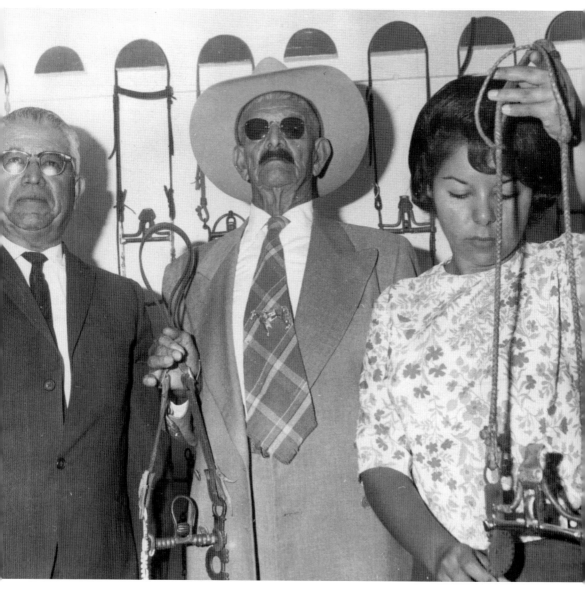

Pedro Moreno

Moreno (center, with son Jesus and granddaughter Lydia) owned a vast property in the Prado area, operating a large dairy, a tomato operation, a cheese factory, and a renowned horse ranch of 100 head. In 1932, famed comedian Will Rogers offered $100,000 for Pedro's stallion King Moreno, and it is said the impeccably dressed and gracious equestrian bowed to the movie star and said, "Thank you for your kind offer, Mr. Rogers, but, a man does not sell his horse."

The 1938 flood prompted the building of a dam that forced Pedro to relocate his family to Norco, where several of his children and grandchildren went on to become outstanding equestrians in their own right. Grandson Henry developed into an outstanding race-horse owner, breeder, and trainer, and two sons, Eddie and Joe Moreno, were first-rate jockeys and trainers. (Corona.)

Gloria Bilotta

In 1971, Norco resident, equestrian, and painter Gloria Bilotta founded the Women's Artists of the West, which today boasts 250 female painters and sculptors and members in 30 states. In 2013, Bilotta was listed as "deceased" by the organization's web site, which prompted a "grave to glory" reception for the artist at the group's annual art show. May 2, 2014, was declared "Gloria Bilotta Day" in San Diego.

Norco Animal Rescue Team

Founded in 2004, NART has roots that extend back decades, when neighbors gave a hand to help an animal in trouble. This large group of equestrians works as a team, and no one person can be singled out for recognition. Each is highly trained to assist and rescue animals in need, including airlifting horses from some truly dangerous terrain.

The Hoof Beats

In 1962, a group of housewives, weary of simply caring for their children's horses, formed Hoof Beats as a way to learn to ride themselves. The club grew to become Norco's first organized precision equestrian drill team, famous for the members' amazing square dancing on horseback. This group of remarkable women also used the club to raise thousands of dollars for charitable donations. (Tamara Black.)

Norco Cowgirls Rodeo Drill Team

Mychon Bowen (left) formed the Cowgirls in 2008, and they have been wowing rodeo and parade spectators ever since. A source of great pride for the community, this nationally recognized drill team was one of only 15 equestrian units selected to participate in the 2014 Rose Parade. Membership is not based simply on skill but on a "strict moral code and image." (Brigitte Jouxtel.)

Bob Cuervo
Residents would often see Bob Cuervo strolling along the street with llamas Charley and Levi after he retired from a significant career of service with the Apollo and space shuttle programs. An exceedingly humble and sharing musician and craftsman with extraordinarily skilled hands, Cuervo is known for his handmade flutes and his hats, ropes, sweaters, and other items woven from llama wool.

Elizabeth Swift
The wonderfully daffy wife of meat company heir Louis Swift, "Libby," built the magnificent Arrow S Ranch, where the Silverlakes event center now stands. She was famed for extravagant birthday parties for her mule Charley and star-studded hunter jumper mule shows to raise funds for ill children and seniors. With the death of her husband, she suddenly sold her ranch and moved back to Chicago in 1956. (Corona.)

Horsetown USA Hall of Fame

The mission of this institution, formed in 2008, "is to honor the trainers, breeders, riders and horses from Norco, California, that have achieved Championship status." The hall's categories are Rodeo, Horse, Equitation, and Trainer. Members of the hall of fame are listed below, arranged by category. Pictured here is Kelli Newton, Hall of Fame Champion Junior.

2008 Champion: Rodeo: Aaron Williams, Ricky Hallam; Horse: Excalibur DDF/Pamela Bell, Promise to be Dunn/Yvette DePriest, Mighty Nice Drummer/Linda Powell, Wyman Oaks Joey Beth/Katherine Steffen, Pioneerspirit JLS/Patrice Tipton, Reckless Lover/Linda Powell, OTB Auryan/David/Shirley Henderson; Trainer: Jerry and Shelley Lunde, Joe Moreno Sr., Nikki McGinnis, and Patricia Visscher; Equitation: Christina Wright, Linda Powell; Book of Nominees: Trainer: Mike Haus; Horse: Antique Fire/Laura and Roy Fleeger; Honorary: Horse: Reckless Lover/Linda Powell, Hail Yeah/Ray Ariss

2009 Champion: Equitation: Kindel Huffman, Paula Baker; Horse: Mary Ann/Danny/Jeanne DeBruce/ Renee Delpino, LCS Ice Princess/Patricia Gesler, Another Dimension Dream Girl/Kathy Miller/Mike Lasley, The Great O Lena/Kelsey Huffman, Lucca Brasi/Kindel Huffman, Totally Bedazzled RA/William Mallory, Dolly Barton/Marian Silverman, GC Lakota/Wendy Blanch, Caballero Del Rey/Ray/Pippa Ariss; Trainer: Jeanne DeBruce, Mike Haus

2010 Champion: Horse: Cole's Rebel Prince John/Jena/Judy Bengtson, OP Rambo/Janet/Caitlin Koss, Burrcrest Rudolph Valentino/Danny/Jeanne DeBruce, GC Elazar/Greg Newton, Grey Gull/Stacy Turner, Infinitee/Margaret Vanden Broek, Mi Little Amigo/Marsha Carey, Lonsum Pin Breeze/Marsha Gagnon, Airegantlee/Gary and Mari Sanderson; Trainer: Paul C. Jones, Stacy Turner; Breeder: Margaret Vanden Broek; Equitation: Judy Bonham

2012 Champion: Horse: Navajo X/Patrice Tipton, Thor/Patricia and Dwight Vichtner, Quechol/Lori Lee Cornia, DeBruces Magic To Do/Danny/Jeanne DeBruce; Trainer: Stacy Lair, Debbie Donnelly; Jockey: Garrett Gomez; Equitation: Rick Wagner, Rachel Pardes; Book of Nominees: Horse: Jester/ Jennifer Wells

2015 Champion: Horse: BSJ Good N Ready/Stacey Turner/Barbara Steinberg, Pendragon FQ/Jose Arambula, Alada Promise/Yvette DePriest, Diamond T's Time to Shine/Amy Toliver, Hillside Farms in Awe/Denise/Laura Purcell, Lady Godiva FQ, Jose Arambula/Johnny Valencia, Merseyside Lovely/Rita Walter/Janalee Holden, LM Idols Commanche Hawk/Amy Toliver, Kavik/Malissa Tarman, Diamond T's Midnight Miracle/Amy Toliver; Junior: Lauren Bell, Kelli Newton; Amateur: Kristin Hicks, Yvette DePriest, Malissa Tarman, Wendy Blanch, Patrice Tipton; Trainer: Mike Haus; Honorary: Breeder: Amy Toliver; Body of Work: Rick Bingham

CHAPTER SIX

Sailors, Doctors, and Scientists

Perhaps no other outside force has had more impact on the modern destiny of Norco than the US Navy. While the community's early fame and reputation rested on agriculture, poultry, and the Norconian resort, the Navy sailed in at exactly the right time with jobs to literally save the rural community devastated by the Great Depression. The Navy also brought some of the smartest professionals on the planet and opened Norco to the world.

The Navy came calling in October 1941. In anticipation of the nation's entrance into World War II, Pres. Franklin Roosevelt authorized both the Army and Navy to procure suitable sites for medical facilities. Resorts across the nation were closed or closing, and they offered facilities that were easily convertible into hospitals.

The Navy agreed to buy the Norconian for $2 million, however, the US government quickly reneged on the agreement, and Rex Clark was only paid in 1946, after winning a protracted legal battle. Despite the lawsuit, following the attack on Pearl Harbor, the Navy immediately began to convert the property into a convalescent facility. It was quickly decided that the hospital would be a permanent institution. During the war, it grew into a gigantic complex with three distinct hospitals, three off-site satellite convalescent hospitals, and 5,000 patients. By war's end, the Norco US Naval Hospital was the Navy's designated West Coast tuberculosis, spinal cord, and polio facility and its national rheumatic fever facility.

Despite a national reputation as a major, freestanding naval hospital, politics closed the facility in 1949. It was stripped and deemed a 700-hundred-acre white elephant. But, soon after, the National Bureau of Standards, charged with the responsibility for the Navy's missile research, development, and testing program, chose the closed hospital for its new facility. A battle between separate naval commands for the site quickly ensued, as the hospital was deemed necessary for Korean War casualties. A compromise was reached, with the National Bureau of Standards moving into the old tuberculosis unit and the rest of the hospital reopened as a wartime general hospital.

Following Korea, the hospital was the Inland Empire's primary military hospital, but politics closed the facility for good in 1957. The Navy's missile complex expanded to include hundreds of more acres and several buildings. Today, the site is home to an elite missile-assessment unit known as the Naval Surface Warfare Center Corona.

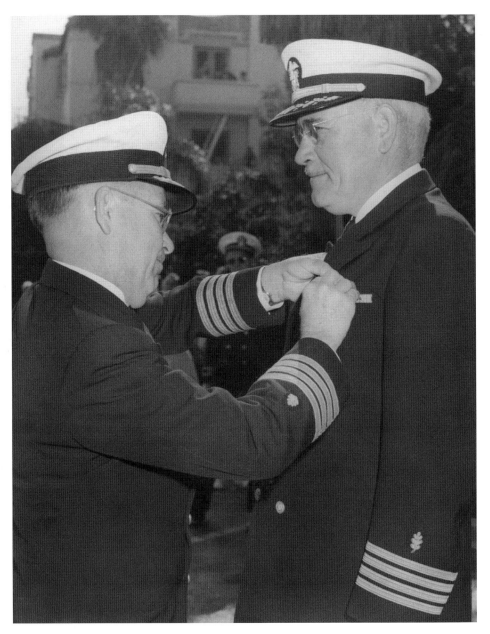

Harold L. Jensen and Leslie Marshall

Decorated for heroism as the chief medical officer aboard the USS *Solace* during the Pearl Harbor attack, Captain Jensen (right) took command in early 1942 of the naval hospital in Norco and battled again to create a top medical facility manned by many of the best physicians in the world—all for his "Sailors and Marines."

In June 1942, hospital executive officer Captain Marshall (left) dropped a bombshell at the weekly Corona Rotary meeting. It was unacceptable that a black sailor had been refused service at a local restaurant, and unless all sailors and Marines were welcomed everywhere, Corona would be off-limits to naval personnel. The prospect of losing Navy purchasing power prompted the beginning of the end of Corona-Norco racism. (USC.)

Waltman Walters and the Mayo Boys

Following Pearl Harbor, the first doctors assigned to the US Naval Hospital were specialists from the Mayo Clinic, likely the nation's finest prewar hospital. Arriving in two separate units, these "high-powered" physicians, known respectfully as the "Mayo Boys," set up the hospital and oversaw growth, from zero patients to over 2,000. Members of Unit II shown here are, from left to right, Richard Cragg, Laurentius Underdahl, Charles Watkins, Waltman Walters, John Camp, Hugh Butt, Mark Coventry, and Donald H. Pattison. Shown in the portrait are Charles and William Mayo.

Captain Walters, who served as chief of surgery and executive officer at Norco, headed Unit II. He later served on Adm. William Halsey's staff and was promoted to admiral.

Itching to get into the fight, the "Mayo Boys," after insistent lobbying, were eventually allowed to go overseas, where they created groundbreaking battlefield medical techniques and treatment. (Mayo.)

Mrs. Harold Jensen

In 1942, Capt. Harold Jensen's wife encouraged local women to volunteer for the American Red Cross Hospital and Recreation Corps, better known as the "Gray Ladies." During World War II, these tireless volunteers served patients around the clock, pushing wheelchairs, changing beds, and teaching tough Marines how to sew to regain damaged finger dexterity. Posing here with the Gray Lady Corps are Captain Jensen (center) and Mrs. Jensen (right of center, checkered dress). (Corona.)

Ollie and Florence Marlow

Florence met her future husband, a corpsman, while working at the hospital. In 1949, as the hospital was shutting down, Ollie was forced to follow an order to dig a deep hole, toss in all the spectacular furniture from the former Norconian Resort Supreme, and burn it. To this day, the image of the beautiful, rare, and expensive furniture being needlessly destroyed angers him. (Marlow family.)

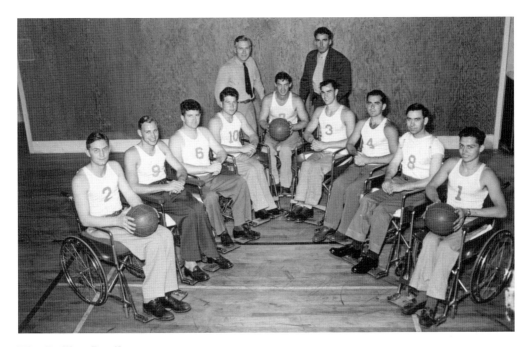

The Rolling Devils

During World War II, treatment of paraplegics was limited, and many combat veterans suffered and died simply from lying in bed and succumbing to infection due to bedsores. The Norco Naval Hospital pioneered a revolutionary new treatment: get the men out of bed and into competitive athletics, particularly wheelchair basketball. At first, the Navy medical high command was resistant to men in wheelchairs playing football, baseball, and tennis. But the results in terms of morale and physical health were so dramatic that high command ordered the go-ahead.

Norco Naval Hospital was designated the Navy's West Coast spinal-cord treatment facility, and Marines and sailors were transferred from every naval hospital west of the Rockies and the entire Pacific theater. As early as mid-1945, through competitive sports, veterans were transformed from angry and depressed young patients with no future to men who led the charge to move paraplegics out of the shadows and into mainstream America by lobbying to enact the postwar Americans with Disabilities legislation.

In mid-1946, Dr. Gerald Gray, a naval reservist and renowned Oakland plastic surgeon, was assigned to the hospital in Norco. His task was to perform painful skin grafts on paraplegics suffering deadly bedsores. While serving as a consulting surgeon at nearby Birmingham Veteran's Hospital, Gray watched a group of wheelchair-bound athletes playing basketball. He rushed back to Norco and immediately formed the Rolling Devils. On March 18, 1947, the Devils were trounced in the first organized game between two paraplegic teams in history at the US Naval Hospital gymnasium.

The Devils, comprised of tough combat Marines and sailors, practiced for hours on end and developed a rough-and-tumble, "just plain mean" brand of basketball. They crushed Birmingham in a subsequent grudge match between the pioneering teams.

Sponsored by the *Oakland Tribune*, the Rolling Devils embarked on the first barn-storming wheelchair basketball tour in history. They received national attention, particularly for John Winterholler, the sport's first publicized star. The team crushed the competition all along the West Coast, culminating in a heavily publicized and packed-house victory over a professional basketball team, the Oakland Bittners. The wheelchair athletes shown here are, from left to right, "Webbo" Weber, Neil Harris, "Smiley" Largey, Bill Ducker, "Spider" Winterholler, "Pistol Pete" Simon, "Smitty" Smith, Mac McNight, and Jerry Fesenmeyer. Standing in the rear are Dr. Gerald Gray (left) and coach "Wild Bill" O'Connell. (Winterholler family.)

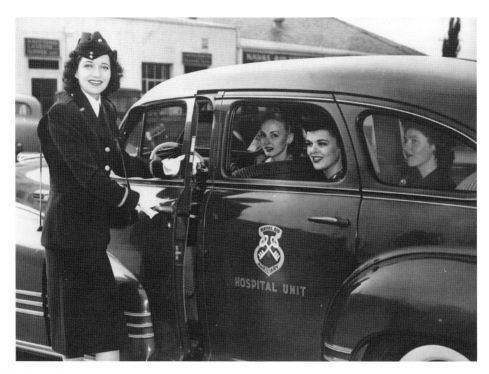

Kay Francis

In the 1930s, Francis was a major star. However, she crossed studio bosses, who retaliated by destroying her career as a warning to other performers to toe the line. In 1941, Francis threw herself into the war effort, entertaining in combat zones and pioneering the Naval Aid Auxiliary Hospital Unit.

During World War II, Hollywood performers entertained troops across the nation and around the world in Army and Navy camps, hospitals, and battlefronts through the USO and Hollywood Victory Committee. Completely forgotten is the Naval Aid Auxiliary (NAA). Begun in 1942 by wives of the most powerful men in Hollywood, the NAA was chartered by the Navy as the first volunteer woman's organization founded to promote welfare and financial assistance and relief to Navy and Coast Guard enlisted men and their families.

At the Norco Naval Hospital, Kay Francis pioneered the NAA Hospital Unit. This was specifically not an entertainment service, instead involving one-on-one, individual visits with patients on a weekly basis. Francis was the Navy's designated "morale officer" at the hospital. Each week, she saw hundreds of patients, bringing with her some "Hollywood friends," including Jimmy Cagney, Bette Davis, Myrna Loy, Cary Grant, and others. Francis also brought beautiful and very appreciated starlets and provided weekly movies, courtesy of each of the major studios. Here, she stands at left with three starlets.

The program became so popular that Francis was asked to implement the NAA hospital service nationwide. Soon, society matrons and pretty girls were visiting patients in naval hospitals from Oakland to New York. However, only Norco, due to the close proximity to Los Angeles, and, to a lesser extent, Long Beach Naval Hospital, where Francis also started the program, enjoyed the unique Hollywood connection. Because of this, patients from Norco were regularly transported to Los Angeles to attend celebrity War Bond Drives, radio programs, special screenings, elaborate studio parties, and sporting events. They even stayed as guests in stars' homes and were provided with a regular Sunday-night box at the famed Hollywood Canteen.

NAA women wore a very stylish uniform, part of a much-criticized Hollywood social rivalry as to who had "the smartest uniform"—the NAA or the khaki-uniformed Volunteer Army Canteen Service. There was resentment among Hollywood folks serving in "authentic" military branches, and "nonessential" service uniforms were frowned upon and actually banned from being worn at the Academy Awards.

Dennis Casebier

Casebier, former physicist, operations research analyst, and department head of the fleet analysis center in Norco, was a key player in one of the most significant stories in Navy missile history.

Despite a Norco presence for almost seven decades, relatively few residents are aware that their community is home to a top-secret Navy missile laboratory, manned by hundreds of some of the smartest people on the planet. In 1951, the National Bureau of Standards (NBS), which had run out of room in its Washington, DC, laboratories, began the renovation of the old Tuberculosis Unit II of the Norco Naval Hospital, coexisting with the reopened US Naval Hospital in the northern section of the old Norconian Resort.

The NBS's primary mission was the development of Navy guided missiles. Every phase of development was to be covered, from theoretical and applied research to construction of experimental parts. Over the next 20 years, state-of-the-art computers were set up for flight-simulation problems, and drop towers and other testing facilities were built. In addition, the facility had a complete fuse-development complex and the only flight-simulation building in Southern California.

In 1953, the Navy felt that a nonmilitary bureau (NBS) should not be engaged in military activities, and the laboratory became the Naval Ordnance Laboratory Corona (NOLC). Essentially, personnel remained the same, but the mission expanded to encompass a new emphasis on fusing systems.

In the late 1950s, problems began to appear in the Navy missile systems, and a conflict occurred that would change the course of missile effectiveness forever. NOLC was not only entrusted with designing, testing, and building missile systems but also evaluating performance. The NOLC Missile Evaluation Department repeatedly reported that there were failure issues during test firings, but the small cadre of evaluators were silenced and eventually fired by their NOLC superiors. Concerned that the NOLC was now going down the path of the World War II torpedo debacle—submariners died when torpedoes failed to detonate or, worse, exploded in the firing tubes—the evaluators went around their command structure and flew to Washington and reported their findings to Naval Command.

The shakeup was swift and dramatic, beginning with the removal of key NOLC personnel and the establishment of the Fleet Missile Analysis and Evaluation Group (FMSAEG), the first wholly autonomous weapons-evaluation group in history.

Curtis Humphreys

Humphreys was a world-renowned naval physicist who was responsible for several significant scientific breakthroughs in radiometry, spectrophotometry, and infrared that led to advancements in missile technologies as well as the development of the heat-seeking missile and made possible the extraordinarily successful Sidewinder air-to-air missile. Humphreys spoke at the 1954 Rydberg Centennial Conference, which at the time was the most distinguished group of spectroscopic and atomic physicists ever assembled. (Corona.)

Frederick Alpers

A prolific scientist who helped develop the first guided missile used in combat, Alpers received multiple awards and had over 60 patents. His work on guidance systems led to the development of many of the most effective missiles in history, including the Talos, Walleye, and Standard. Legend has it that China Lake could not make the famed Sidewinder work, but Alpers solved the guidance problem in two days. (Corona.)

CHAPTER SEVEN

Norco High Cougars

Prior to 1967, when Norco High School opened, local students attended Corona High. Almost immediately after the new school's opening, a two-decade rivalry began between the Norco Cougars and the Corona Panthers. Since that time, several high schools service the Corona-Norco Unified School District. Students attend their senior high school based not only on its proximity but because they like a certain coach, band instructor, or wish to participate in a specific academic program only offered at one facility.

Today, there is another school in town, John F. Kennedy Middle College, which, through a special program with Norco College, caters to young people wishing to concurrently enroll in both institutions and simultaneously earn a high school diploma and a college associate's degree.

This chapter, however, focuses on graduates from Norco High who have gone on to make a mark both outside and inside the community in many fields, including athletics, politics, education, commercial business, and construction.

Norco High's Friday night football game is a ritual for residents and players. Some players have earned full-ride scholarships to many of the best colleges and universities in the nation. Norco High has also produced some of the finest softball and baseball players in the nation: Teagan Gerhart, a standout pitcher at Stanford; Emily Lockman, currently a starting pitcher at Nebraska; Wally Crancer, formerly with the Orioles organization and now establishing a substantial career as a coach; and Daron Kirkreit, a pitcher for the US National Baseball Team in the 1992 Olympics. More recently, Norco High alumni Jordan Campbell, Jared Koster, and Carl Bradford were drafted into the NFL. Ricky Hallam and Aaron Williams have both made their mark on the rodeo circuit.

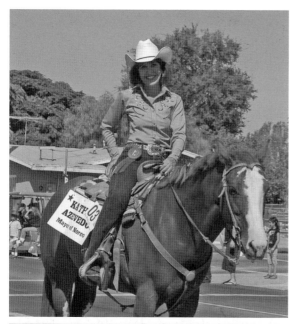

Kathy Azevedo
Councilwoman Azevedo was the first Norco High graduate elected to the Norco City Council. It is claimed that she "bleeds Norco blue." Known citywide as "Kathy," she was also one of the most popular councilpersons ever elected, serving 12 years. Perhaps her greatest claim to fame, among many, is branding and marketing Norco as "Horsetown USA." (Brigitte Jouxtel.)

Carrera Allred
Allred graduated from Norco High in 2011, finishing as AFJROTC Cadet Corps commander with a rank of cadet colonel. She went on to Cal State San Bernardino's AFROTC Scholarship program, where she served as cadet wing commander, was named outstanding undergraduate of communication studies, graduated summa cum laude, and is the first Norco High AFJROTC graduate to be commissioned in the US Air Force.

Damion Stafford
Stafford (right) persevered over great adversity to score football honors at Norco High, Chaffey College, and the Nebraska Cornhuskers, where he earned All–Big Ten honors. Today, Stafford plays strong safety for the NFL's Tennessee Titans. Kristine Breaux McCullough (left) is a Norco High academic counselor who not only bleeds Norco blue but has also encouraged and guided many athletes toward college degrees. (Kristine Breaux McCullough.)

Sonya Guercio Curl
Mark and Peggy Curl own and operate the Sixth Street Deli, a Norco institution. Their daughter Sonya stepped in to manage the thriving family business and has followed her parents' tradition of good food and dedication to community service. Very seldom is there an event of any kind in the city where the Sixth Street Deli wagon is not present, with Mark, Peggy, or Sonya cooking away.

Matt Logan

Graduating from Norco High in 1985, Logan has gone on to become one of Southern California's great high school football coaches. Under Coach Logan, the Corona Centennial Huskies have won state and Southern Regional championships, nine California Interscholastic Federation (CIF) championships, and 13 league championships and established multiple team and player national and state records. As of this writing, 95 of his players have earned college scholarships. Logan himself has earned multiple coaching honors, including the following: Russell Athletic National Coach of the Year, Schutt West Coach of the Year, Press Enterprise Sportsman of the Year, NFL/ABC Coach of the Year, CalHiSports State Coach of the Year, California Coaches' Association Southern Section Coach of the Year, All-Area Coach of the Year, *Los Angeles Times* Coach of the Year, CIF Coach of the Year, League Coach of the Year, and NFL Coach of the Week. He has been selected to coach in the US Army All-American Bowl, Shrine Game, Southern California Bowl, Cal/Florida Bowl, Gridiron War, and Inland Empire All-Star Classic. (Matt Logan.)

Tamara Ivie

An outstanding all-around athlete at Norco, Ivie went on to Cal State Northridge, one of the best Division I teams in the nation, where she was part of the Matadors' "Murderers Row," which set a NCAA single-season team record of 34 home runs. She hit one of only two home runs ever against UCLA's famed pitcher Lisa Fernandez, earned All-American honors, and was a two-time All-Western Athletic Conference selection. Ivie, a diehard California Angels fan, dreamed of playing professional baseball. Her dream came true when she earned a spot on the famous Colorado Silver Bullets under hall of famer Phil Niekro. This was followed with Tamara playing for the Buffalo Nighthawks in the Ladies Professional Baseball League.

Ivie came out of retirement as a college coach to play professional softball for the Virginia Roadsters (earning All-Star Honors) and, after another retirement, the Arizona Heat. After serving as head softball coach at Santa Monica Junior College, Ivie, in 2006, earned a gold medal playing for the USA in the Women's Baseball World Cup, where she batted .477.

In 2007, Tamara Ivie, as one of the top female baseball stars in the nation, was invited to work out with the Long Beach Armada of the Golden Baseball Independent League in an effort to become only the second woman in history to play professional minor-league baseball. Coach Darrell Evans stated, "Tamara has the ability to play at this level, or I wouldn't have her out here. She is a tough, determined, skilled ballplayer and a pleasure to have in spring training. It's not easy for any player to make this team, but she will have a legitimate shot." Tamara's pioneering play attracted quite a crowd at cozy Blair Field and directly led to other women getting tryout opportunities.

Over the years, Ivie alternated between playing professional softball and baseball and serving as assistant coach for Eastern Michigan, New Mexico State, and the Arizona State Sun Devils. Today, Ivie, who once hit a two-run homer to put the Northridge Matadors into the College Softball World Series, is mama to four beautiful girls and "laughs every day." (Tamara Ivie.)

Melanie Oliver
Highland Elementary teacher Melanie Oliver (center), teaching at the very school she attended as a child, was shocked when county superintendent of schools Kenneth Young (left) and Principal Jason Scott (right) surprised her with the 2016 Riverside County Teacher of the Year Award. A teacher's teacher who dreamed of being a teacher as a child, Oliver feels "blessed every day to be doing her dream job." (County Schools.)

Bob Hicks
Hicks graduated from Norco High in 1979, served in the Marines, and today works as founder and president of Total Transportation Logistics, Inc. The extremely successful company specializes in transporting around the globe everything from high-value electronics to priceless artwork. However, his true claim to fame is his dedication to community service, particularly his work supporting Norco's Christmastime Parade of Lights and Winter Festival. (Wanda Crowson.)

Eric Linder
Linder is the first Norco High graduate to be elected to the California State Assembly, serving as a Republican representing the 60th District. The young assemblyman is active, accessible, and very popular in Norco, effective across party lines, and extremely hands-on throughout his jurisdiction within western Riverside County.

Jonathan Kahan
A 2015 graduate, Kahan has enjoyed remarkable success as a leader in Boy Scouts and the Air Force Junior ROTC program. However, he holds another unique accomplishment; his $1,000 contribution, left over from his successful Eagle Scout project, was the first donation made to construct the George A. Ingalls Veterans Memorial Plaza. This act inspired others to fund a project that some predicted "would never happen."

Todd, Garth, and Toby Gerhart
Todd Gerhart, a 1980 All–Riverside County running back while at Norco, went on to play for the Denver Gold of the United States Football League. His sons followed in his footsteps, with Garth (above) earning All-California honors at Norco and All–Pac 12 honors at Arizona State. Today, he plays center for the Green Bay Packers.

Toby (below) was one of the greatest high school running backs of all time, earning Gatorade High School Player of the Year honors while rushing for 9,662 yards. At Stanford, he was a unanimous All-American, and he was drafted by the Minnesota Vikings in 2010. Today, he stars for the NFL's Jacksonville Jaguars. The boys' mom, Lori Gerhart, and sisters Teagan, Whitley, and Kelsey were also dominant athletes. A third son, Coltin, currently plays football and baseball at Arizona State. (Both, Gary Evans.)

Eva LaRue

This talented beauty (seen here starring in *The Annette Funicello Story*) entered show business at the age of six. The former homecoming queen landed a string of leading parts in television and films before earning starring roles on *All My Children*, *The George Lopez Show*, and *CSI: Miami*. In 1997, LaRue returned to Norco to hold a fundraiser for an old friend suffering with cystic fibrosis. (CBS.)

Dalton Shepard

Shepard has been involved in the Junior Bull Riding Association since he was two years old, beginning with "mutton bustin' " and working his way through calves, steers, and peewee bulls. He is currently in the Junior Bull Division. In 2012, he was the National Steer Riding Champion, and he has won has over 65 champion and reserve champion belt buckles. (Nancy Shepard.)

Paul C. Jones

Jones is the most successful quarter-horse racing trainer in history: $76,455,097 in purses, 20,701 starts, 3,839 winners, and 411 stake winners. He is the only trainer in history to win 13 consecutive American Quarter Horse Association World Champion titles (2002–2014). Jones is a three-time All-American Futurity winner, a six-time Champion of Champions, and he trained Snowbound Superstar, a legendary quarter horse with the most consecutive wins in history. (Marin Jones.)

Pat Harlow

At Norco, Harlow (center) played football and basketball, winning All–Riverside County honors in both sports. As an offensive tackle, he attended the University of Southern California, earning All-American honors and the Morris Trophy as the best offensive lineman on the West Coast. A first-round NFL draft pick, Harlow played eight years for the New England Patriots and Oakland Raiders. (NHS.)

Gina Boster
Gina definitely bleeds Norco blue. Seen here as a Norco High student, she returned to teach at her alma mater and served as assistant principal. Boster is credited by many with establishing at Norco the groundwork for one of the best agricultural programs in the state. She later became principal at Corona Fundamental Intermediate School and today serves as the district's director of career technical education. (Gina Boster.)

Larry Nugent
An outstanding distance runner, Nugent returned to Norco High and became an extraordinary track and cross-country coach and teacher for over three decades. The Nugents were a pioneering Norco family, producing a long line of phenomenal athletes at both Norco and Corona High. During World War II, five Nugent brothers were in uniform and were lauded for their service by the secretary of the Navy. (NHS.)

Robin Grundmeyer and Carole Lindsey Norco born and raised, these sisters are an education force. Returning to Norco High as hugely popular teachers, this pair worked to transform the already well-known agriculture department and Future Farmers of America chapter into a nationally recognized and multi-award-winning educational program. Tough farm girls, Robin (left) and Carole (right) once wrestled a bad guy to the ground to save a deputy sheriff! (Lindsey family.)

Renee Parish

In this photograph, Renee Parish (fourth from right) and her board of directors present a donation to the City of Norco. She serves as senior pastor at the Beacon Hill Assembly of God, where she leads a multiethnic, multi-language congregation that includes members from many nations. The church sponsors Tongan- and Swahili-speaking fellowships. Parish was the first female pastor to serve on the Southern California District Council of the Assemblies of God. (Parish family.)

Gary Parcell
Coach Parcell is one of many graduates who have returned to Norco High to instruct and lead by example: in Gary's case, he coaches baseball and teaches life 101. A successful sporting-goods representative by trade, his passion is America's pastime. The list of his ballplayers who have gone on to play in college and professionally is long, as is his number of championships. (Gary Parcell.)

Eric Briddick
Norco's "police chief," a longtime resident, was put in charge of Riverside County Sheriff's oldest law-enforcement contract city in 2014 because of his impressive list of accomplishments, "a work ethic second to none," and an understanding of "Norco's western lifestyle." Highly visible, Briddick, seen here at left during a meeting with residents, is well known and liked within a community that appreciates his professional and friendly approach.

Nancy Shepard and Joe Centeno
Shepard learned the business of nuts and bolts from her parents, cigar-chewing Michael Brande and wonderfully kind Nicolina, who built Norco Hardware into a local landmark. In 1977, fellow Norco High graduate Joe Centeno started at the bottom with the ACE franchise, and today he works as the extremely knowledgeable store manager. Both are known for their charitable efforts.

Christy Torres
Torres is the general manager of Polly's Pies, a hugely popular restaurant in Norco. She works by the philosophy that giving back to the community is a must. Torres worked her way up through the ranks at Polly's in outlying cities, with the goal of "coming home." She and her crew regularly support community events, serving delicious baked items and giving away free pies.

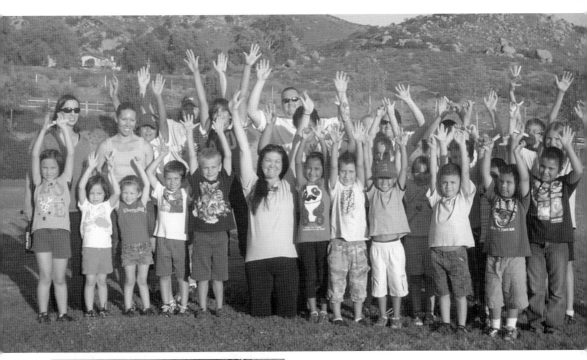

Kara Lubin

In 1993, Lubin (front, center) taught children who were challenged with learning disabilities, uninspired, angry, and had lots of energy. She searched for a way to calm, inspire, promote health, and "teach these amazing children"—the 100 Mile Club was born. The goal set for the kids is to run 100 miles and earn a gold medal. The program, centered in Norco, has exploded internationally. There are over 30,000 participants in California alone.

Debra McNay

McNay began in 1980 with the Norco Parks and Recreation Department as a 19-year-old, part-time clerk typist. She worked her way to executive secretary and, eventually, city clerk in 1996. She held that position until 2008, when she accepted a similar role in Rancho Cucamonga. Widely respected, McNay is known for her charitable work, mentoring, organization skills, and integrity.

Greg Vineyard

Graduating from Norco High in 1990, Vineyard (seen here with assistant manager Sara Piscatella) soon began a long career with the Stater Bros. supermarket chain. He returned to Norco 13 years ago as the popular manager of the company's Hamner Avenue store. Vineyard believes in giving back and is particularly involved with the Norco senior community, supporting several food-bank projects and holiday dinners.

Don Trenholm

Trenholm (second from left) is the chief executive officer of family-owned Act I Construction, a respected, Norco-based builder of projects for the military, schools, hospitals, and other facilities. Working with his wife, Tiffany, and crew of master craftsmen (pictured), Trenholm built the George A. Ingalls Veterans Memorial Plaza. He made sure the magnificent memorial was finished on time, and he added many additional features out of his own pocket.

Gary Evans

This skilled photographer is the visual chronicler of Norco's history, particularly Norco High School, his 1981 alma mater. A regular at sporting events, parades, concerts, and all manner of activities, Evans transforms simple moments into treasures. With cameras at the ready around his neck, Evans can be seen quietly capturing touchdowns, a struggling freshman trumpet section, a group of veterans shooting the breeze, and wonderful sunrises and sunsets.

Nick Kliebert

An outstanding baseball player at Norco High, Kliebert earned All-League, California Interscholastic Foundation, Riverside County, and California All-Star honors, was a valedictorian, and won a scholarship to Pepperdine University. He helped Pepperdine to three West Coast titles and was named West Coast Conference Scholar Athlete of the Year. After a promising season of minor-league ball, Kliebert walked away, completed law school, and today works in the Riverside County District Attorney's office. (Gary Parcell.)

Frankie Scagnamiglio
Scagnamiglio began working part time for the City of Norco in 1986. In 1990, he was promoted to full-time animal-control officer, and in 2013, he was named animal-control superintendent. A friendly, gregarious man, he loves animals. (As a child, he brought home many a stray dog and even a goldfish, which he kept alive for two years!) He is highly respected in his field. (Frankie Scagnamiglio.)

Aaron Hake
Aaron Hake began as the editor of Norco High's student newspaper and simultaneously was appointed to serve as the chairman of county supervisor John Tavaglione's youth council. He has served US senator Dianne Feinstein, founded a program to support underprivileged high school students, and currently serves as the City of Corona's treasurer and as a Riverside County planning commissioner, which includes overseeing his hometown, Norco. (Aaron Hake.)

Darin Schemmer

Graduating at the top of his class at Norco High in 2003, Schemmer (center) enrolled as a history and political science major at UC Riverside and began a truly remarkable career in politics. For his efforts as an 18-year-old GOP volunteer, he was invited to Pres. George W. Bush's 2005 inaugural. Today, he serves as the communications director for Riverside County supervisor John Benoit (right). (Brigitte Jouxtel.)

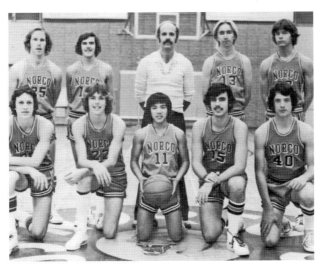

Curt Wardle

Lefty Wardle (first row, second from left, with 1977 Norco High junior varsity basketball team) pitched three seasons of relief for the Minnesota Twins and Cleveland Indians. His shot at the big leagues followed a minor-league season in which he compiled a 6-1 record with 17 saves for the Orlando Twins. Wardle's first major-league start was against the Angels, his favorite boyhood team. At the time, he expressed shock that he was not paying to see players, but that people were paying to see him!

Shane Spicer
In 1992, Spicer caught four passes and scored a touchdown in the fourth quarter of the championship game to ensure Norco High's first perfect season and division title. In 2011, his championship ring appeared on eBay, and the mayor of Norco purchased this long-lost memento, engraved with Spicer's name. During a Norco City Council meeting, the mayor presented the ring to a grateful Shane Spicer and his family. (NHS.)

Jason Bretsch
Bretsch was a Norco All-League second baseman and wide receiver, and he went on to play and coach baseball at Cal Baptist College and at Chaffey College. He grew up working in the family business, Ken's Sporting Goods, started by his father in 1976. Today, Jason Bretsch serves as team sales manager. He bleeds Norco blue, serving over 30 years as a linesman at Cougar football games. (Jason Bretsch.)

Garrett Parcell
Upon graduating in 2003, Parcell enrolled at Cypress College in the hope of continuing to play baseball. His coach quickly converted the former first baseman/catcher into a relief pitcher, due to a newly discovered 90-mile-an-hour fastball, which led to a San Diego State scholarship and a baseball career. Parcell surprised all when he walked away from playing to represent players as a fast-rising athletes' agent. (Gary Parcell.)

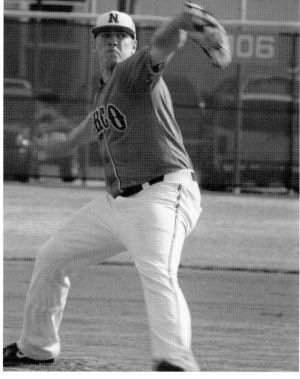

Matt Hobgood
One of the greatest baseball players in Riverside County history, Hobgood hit .475 with a nation-leading 21 home runs in his senior year at Norco High. As a pitcher, he built an 11-1 record and an ERA of .092. Hobgood was named Gatorade National High School Player of the Year and was drafted in the first round by the Baltimore Orioles. (Gary Parcell.)

Norco High Hall of Fame

Candidates for the Norco High Hall of Fame qualify in one of two categories: athletes (several for multiple sports), and coaches/administrators/community members (Distinguished Service). Inductees into the school's hall of fame are as follows:

Football: Randolph Augustus Brown, David Neal Nugent, Daniel Todd Brown, Todd Wayne Gerhart, Stephen Wayne Nugent, Randy William Berry, Patrick Christopher Harlow, Gary Todd Montgomery, David Evans Mundt, Alan Krueger, Curtis Showalter, David Kelley, Matt Logan, Shawn Sowder, Terry Engle, Pete Becker, James Craig, Kyle Wacholtz, Shay Muirbrook, Shane Park Gentis, Michael Joseph Sanchez, Steve Campbell, Trevor Jay Roberts, Marcus Guzman, Kendall King, Ray Leon Esparza, Joshua Ready, Toby Bo Gerhart, Dean Wade Hinson, and Garth Gerhart

Baseball: Harry Fish, Ralph Millard McDaniel, Michael Edward Darr, Jeffrey Alan Oberdank, Gary Robert Donaldson, Darryl Kile, Chris Kruswicki, Randy Curtis, Linny Smith, Daron Kirkreit, Rudy Arguelles, Walter Crancer, Garrett Parcell, Grant Ryan Johnson, Nicholas J. Kliebert, Kevin G. Olson, and Scott Donaldson

Basketball: Twila Sue Collins, Rebecca Lynn Swift, Bradley John Husen, Monica Jo McDowell, Lori Hribar Gerhart, Tess Ensley Husen, Diane Lee Vaughn, Amy Winderlich, Justin Norman, Erika Rayne Arriaran, Jodi J. Sandow, Heather (Hansen) Grassia, and David Norris II

Swimming: Danny Ray Lockhart, Sandra Joan Meckoll, Cynthia Louise Gillespie, and Stephanie N. Netzley

Wrestling: Randy Allen Campbell, Bobby Kelsoe, Steve Harris, Gus Gutierrez, and Chris Curtin

Track: Darrell Willis, Sara Standley-Gonzalez, Erin Wayne, LaRonda Doyle, Deborah Hart Williams, Stuart Clark Gonzalez, Julia Cuder, Cyndie Snow, Kurt Siebert, Kari Snow, Alan Lee Bash, and Bryan Snow

Softball: Lisa Dawn Anderson, Michelle Phillips-Biernat, Kym Coons, Michelle Joland Hummell, Tamara Ivie, Daniela Urincho, Kaylyn M. Castillo, Karen Vestesen-Emanuele, and Teagan Gerhart

Soccer: Erin Rico

Volleyball: Tinette Vaillancourt Schierbeek, Kristin Harris, and Dana Lee Carlson (Czubakowski)

Cross Country: Michael William Melendez, Bruce Lincoln Schulte, Michael R. Libutti, Kristy Dawn Mueller (Irwin), Persephone Powell, Gerald A. Toussaint, Steven Edward Gladwell, and Steve Strehlow

Distinguished Service: Chester Ray Nicholson, Paul "Pappy" Chastain, Betty Campbell, Dr. Lawrence Clair Nelson, Phil Donohue, David R. Reid, Dr. Robert Nelson, Neal Campbell, Don Harris, Jim Garcia, David Edwin DiPaolo, Gary Campbell, Dennis Pinnecker, Danny Gonzales, James Floyd Cunningham, Benjamin S. Gonzalez, Gary E. Parcell, Bobby "Bobbo" Torres, Larry Nugent, Jerry W. Smith, Betty J. Wells, Kathy Ann Azevedo, Bob Doerr, and James Foree

Mike Darr

Darr (No. 42), pictured with the 1974 Norco basketball team, was one of the greatest all-around athletes in Norco High history. He was the first to capture MVP honors in three sports: football, basketball, and baseball. Leading the Cougars to their first major championship in history (baseball) in 1974, Darr signed with the Baltimore Orioles and made the big leagues with the Toronto Blue Jays in 1977. (NHS.)

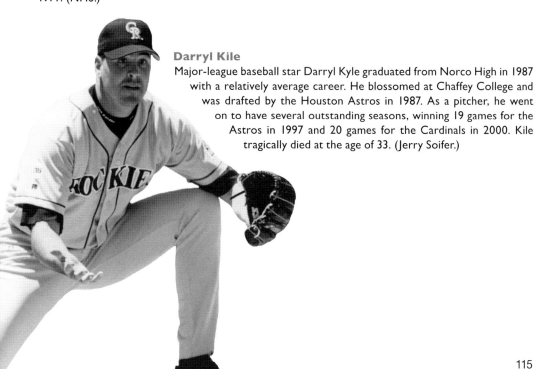

Darryl Kile

Major-league baseball star Darryl Kyle graduated from Norco High in 1987 with a relatively average career. He blossomed at Chaffey College and was drafted by the Houston Astros in 1987. As a pitcher, he went on to have several outstanding seasons, winning 19 games for the Astros in 1997 and 20 games for the Cardinals in 2000. Kile tragically died at the age of 33. (Jerry Soifer.)

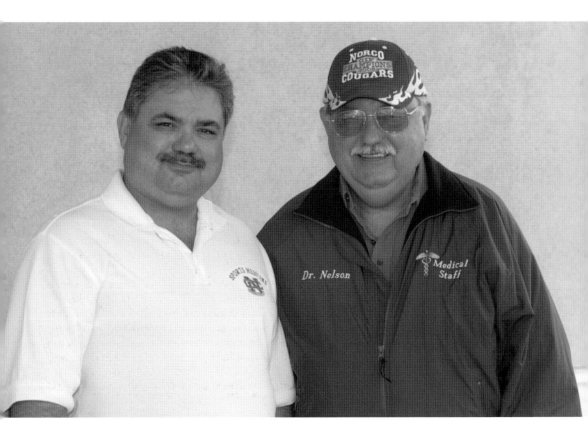

Doctors Nelson and Nelson!

The Nelsons, father and son, have been caring for Norco residents for over half a century. In particular, they have treated Norco High football players since the day the school opened. Both men bleed Norco blue.

Lawrence "Doc" Nelson (right) retired in 2005 after practicing medicine for more than 40 years and was one of the last physicians to make house calls. A graduate of Corona High School and UC Irvine Medical School, Doc returned to open his practice in Norco in 1965. In 1968, he took on the responsibility of physicals and medical care for the brand-new Norco High Cougars football team. Known for his quick and accurate diagnosis of injuries, treatment, and care for players, Nelson was considered a "valuable player" to a team that, in 1992–1993, won 28 straight games and two California Interscholastic Federation titles. For his long service, Dr. Lawrence Nelson was inducted into the Norco Athletic Hall of Fame.

Robert Nelson (left) was born at the old US Naval Hospital in Norco and grew up to play guard for the Cougars football team. He later served as a Navy corpsman. After graduating from the University of Nevada Medical School, he joined his father's practice in 1988, as well as taking over for his dad as the Cougars' team physician. Robert is not only a well-regarded family-practice physician but is also a very astute businessman (along with his son Robbie Nelson). Under the banner Citrus Valley Medical Associates, Dr. Nelson has grown the Norco Medical Group, started decades earlier by his father, into a full-time medical provider. The firm, with a significant, professional medical team, is housed in a distinctly modern clinic overlooking Norco. It is the largest and most comprehensive such facility in the community. (Nelson family.)

Erika Arriaran

In 2005, Arriaran (third row, second from right) was likely the best high school girls' basketball point guard in the nation. She received multiple honors, including the following: *Parade* magazine National Player of the Year; *Los Angeles Times* Girls All-Star Team; top player in her class by Full Court Press; McDonald's All-American; State Farm/Women's Basketball Coaches Association Player of the Year Award; and Inland Valley Player of the Year Award (twice). She went on to play at the University of Texas and professionally with Germany Herner in Europe.

Led by Arriaran, the 2005 Norco High Lady Cougars were undefeated in season play and 28-1 overall. Their single loss eliminated them from the California Interscholastic Federation Championship series. Shown here are, from left to right, (first row) Christine Fitzpatrick, Kaylyn Castillo, Deanna Moreno, Faith Zulauf, and Brittani Philbrook; (second row) Shelley Hamlett, Kasey Philyaw, Kayla Huckabee, Lexi Fowler, and Cassandra Kennison; (third row) coach Rick Thompson, Priscilla Angeloni, Courtney Wysocki, Erica Arriaran, and assistant coach James Foree.

"Erika fever" gripped Norco, with fans packing gyms wherever she played. After each game, little girls and boys—and their parents—clamored for autographs. However, Arriaran was a devoted team player, on several occasions disappointing fans because she refused to score for entire games. Instead, she passed the ball to teammates and insist they take shots.

Arriaran and a few of her Lady Cougar teammates were also involved in a different type of legendary incident. One night, the players secretly slipped into the locked gym after hours to shoot baskets and listen to music. Near midnight, they caught the attention of local deputies, who startled the girls with their flashlights. Blinded by the glare, the girls did not realize who was approaching and, fearing an attack, slammed the door in the deputies' faces. This prompted a call for backup, which included a canine team and helicopter. The terrified girls frantically phoned their coach, Rick Thompson, who thought the call was a practical joke. He quickly learned from a 911 dispatch operator that his players were in fact at the center of a siege, and he rushed to the scene, still in his pajamas, to rescue his cowering Lady Cougars. (Rick Thompson.)

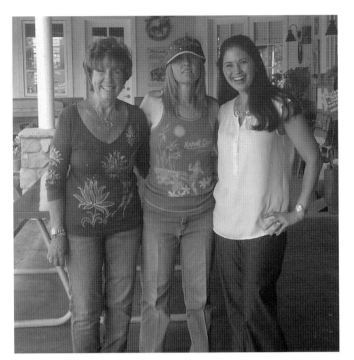

Cassandra Sanders-Holly

Dr. Sanders-Holly (right) is a pediatric clinical specialist who utilizes the movement of a horse (hippotherapy) to dramatically improve motor skills and sensory input for children with cerebral palsy, spinal-cord injuries, and similar issues. Sharon Smith (left) and her daughter Cassie (center) have lent their fabulous ranch and horses to create with Sanders-Holly and dozens of volunteers the truly amazing Leaps and Bounds Therapy Center. (Cassandra Sanders-Holly.)

Tyler Madery

A recent graduate, Madery has nevertheless distinguished himself as a tireless and extremely capable field representative for California state senator Richard D. Roth. Madery frequently accompanies and/or represents the senator at a wide variety of Norco events, including grand openings for businesses, chamber of commerce events, and Eagle Scout Courts of Honor, and he is a regular attendee of Norco City Council meetings. (Richard Roth.)

Debbie DiThomas

Dr. DiThomas is currently the superintendent and president at Barstow College. She spent 30 years with the Riverside Community College District, serving as chancellor of student services and operations, interim vice and associate chancellor, and interim Norco College president. She is a member of Norco's well-known and huge Brown family, who are legitimately famous for their extraordinary athleticism. (Barstow College.)

KAYLYN CASTILLO

| Catcher | Chicago Bandits |

Kaylyn Castillo

Fiercely competitive, Castillo went from walk-on at Arizona State University to starting catcher to All-American and finally to signing contracts with the Akron Racers and Chicago Bandits of the National Professional Fastpitch League. She currently plays for the Shining Vega professional softball team in Japan. Castillo, whose work ethic is astonishing, excelled at a number of sports while living in Norco. (Chicago Bandits.)

Terry Piorkowski

Terry is a longtime Norco resident who began with the city in 1986 as a part-time meter reader. Today, he serves as the City of Norco Public Works superintendent. Extremely capable, Piorkowski is the go-to guy for problems ranging from major water leaks to potholes. With a miniscule budget, he gets an extraordinary amount of work done for residents.

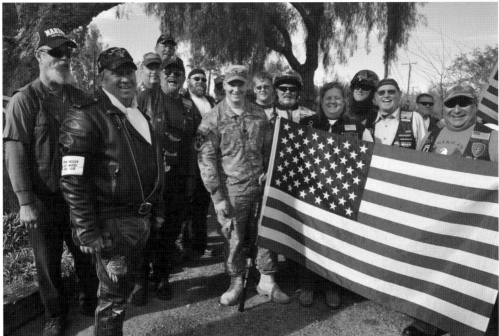

Jason Fairchild

On December 21, 2012, thanks to a two-day social-media blast in response to Jason Fairchild's dissatisfaction with his friends killed in action not being met when "coming home," 4,000 locals lined Sixth Street in Norco to welcome home Jason himself, a 20-year-old wounded warrior (seen here at center with his Patriot Guard escorts). Trained as a sniper, Fairchild sustained injuries during an ambush in Afghanistan. (Brigitte Jouxtel.)

Art Mejia

Energetic Mejia (left) hails from two pioneering Corona-Norco families (the Mejias and Ramirezes) with a strong tradition of political activism and education whose roots in the community go back 100 years. Mejia is blessed with many friends, including Jeff Nelson (center) and Brent Westmoreland (right). He has a unique claim to fame: organizing small and large events via social media that bring together hundreds of Norco High graduates. (Art Mejia.)

Mary Higelin-Fernandez

Mary's roots in Norco are truly deep: the Higelins go back decades and have strong ties to the naval base in Norco. Her father, Joe Fernandez, is a longtime businessman known for his extraordinary charity work. Mary is the owner-operator of Definitions Salon & Spa. Like her father, she is an astute businessperson dedicated to giving back to her community.

Brandon Cunniff

Cunniff was instrumental in leading the Cougars to a Mountain View baseball title in 2005. He earned league MVP honors, was named All-County, and went on to a stellar pitching career at Cal State San Bernardino. After fighting for three years in the independent minor leagues and nearly quitting, persistence paid off. Cunniff became a major-leaguer, pitching relief with the Atlanta Braves in 2015. (Gary Parcell.)

Kyle Panzer

Eagle Scout and certified electrician Kyle Panzer and his high school buddy Jason Alexander played an unsung, unappreciated, but key role in the building of the George A. Ingalls Veterans Memorial. In sweltering heat, they donated their time not only to assist in the electrical installation but also to perform the grueling and backbreaking task of digging the extensive trenches needed to light the nearly half-acre plaza.

Stacy Azevedo Nicola
Nicola (right), who served Sen. Jim Batten as an area representative, is a sought-after political consultant who has successfully guided several city and county election campaigns, including her mother's, Kathy Azevedo (left). Nicola is keenly interested in education, teaches political science at a local university, and is the chair of the Citizen's Oversight Committee for the recently passed school district construction bond. (Azevedo family.)

Evita Tapia-Gonzalez
Tapia-Gonzalez, seen here with Colin Powell, served as Sen. Bill Emerson's district representative, then moved into education and today serves as the public relations specialist for the Corona-Norco Unified School District. However, she holds another distinction that is completely forgotten: on March 9, 2000, she scored the lone Norco run to upset Moreno Valley, the No. 1 high school softball team in the nation, 1-0.

Rickey Hallam

This young bull rider is to be watched: his goal is to be the best in the world! Hallam started riding calves at age six, has since earned a pile of belt buckles, and, at age 20, took home the 2013 Santa Maria Pro Bull Riders crown. He is the Professional Rodeo Cowboys Association (PRCA) Queen Creek Arizona Bull Riding champion. In his hometown, he claimed the PRCA Norco Bull Riding title. (Matt Cohen.)

Kevin Olsen

When Olsen was 10, a rival Little League coach, certain the young pitcher would make the majors, asked for his autograph. Sure enough, 15 years later, Olsen was pitching in the big leagues. He was an All-League pitcher at Norco, Orange Empire Conference Pitcher of the Year at Riverside City College, and Big 12 Conference Pitcher of the Year at Oklahoma and played three seasons with the Florida Marlins.

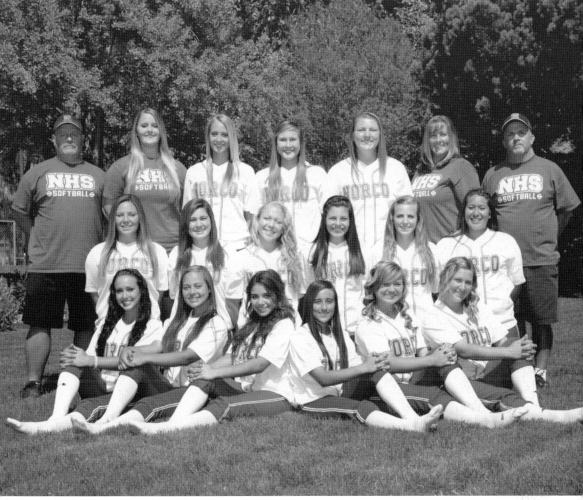

National Champions

The 2012 Norco High girls softball team was only the second squad in the history of the Inland Empire to win a national title (Fontana High's football team was the first, in 1987). The Cougars were ESPN's number one team in the nation. This wrecking crew also won the CIF Southern Section Division I title, was ranked number one in the CalHiSports state rankings, and won the Tournament of Champions in Arizona. And on July 21, 2015, the *Press Enterprise* named the 2012 Cougars the top girls softball team in the history of Riverside County—the "Greatest of All Time!" Simply put, they were unbeatable.

Pitcher Emily Lockman, the Gatorade California State Player of the Year, backed by an infield of five Division I recruits, threw 21 shutouts. The team played one of the toughest schedules in the nation, during which "the Queens of the Diamond" outscored opponents 180-27. Shown here are, from left to right (first row) Kylie Reed, Amanda Sandoval, Kristina DeLaluz, Brianna Rocha, Tiffany Samsoe, and Jackie Hooper; (second row) Haley Gilham, Jenny Troilo, Emily Lockman, Jessica Angulo, Heather Smith, and Ashley Goodwin; (third row) Dave Angene, Nicole Angene, Savannah Clark, Abby Lockman, Taylor Koenig, Beth Windham, and Richard Robinson. (Rick Robinson.)

INDEX

INDEX

AN IMPRINT OF ARCADIA PUBLISHING

Find more books like this at
www.legendarylocals.com

Discover more local and regional history books at
www.arcadiapublishing.com